OUT OF THE

Approaches to Contextual Practice within Fine Art Education

Papers presented at the
'Out of the Bubble' symposium held at
Central Saint Martins College of Art and Design,
London, March 1999.

The 'Out of the Bubble' symposium was co-ordinated by John Carson and Judith Rugg with research and administrative assistance from Isobel Bowditch

Publication edited by John Carson and Susannah Silver.

Acknowledgements: With grateful thanks to Lynne Stackhouse for assistance with text transcription as well as to the facilitators, supporters and sponsors of the 'Out of the Bubble' symposium, principally Central Saint Martins College of Art and Design / The London Institute, University of Plymouth (Exeter School of Art and Design) and London Arts. Special thanks are due to Chris Wainwright and Tim Eastop and to Richard Layzell (aka Bailey Savage) for his keyhole address which opened the symposium. Cover photo and conference photos by Andrew Watson. Inside front and back cover images from placements and external projects by Central Saint Martins B.A. Fine Art students from 1990-1999

ISBN 0947 784 527

Published by The London Institute / Central Saint Martins College of Art & Design and London Arts

Central Saint Martins College of Art and Design
107 - 109 Charing Cross Road, London WC2H 0DU
Tel: +44 (0) 20-7514-7000

London Arts, 2 Peartree Court, London EC1R 0DS
Tel: +44 (0) 20-7608-6100

To receive a version of this text in braille please contact:
Public Affairs Unit, London Arts, 2 Pear Tree Court, London EC1R 0DS.
tel 020 7608 6100 text phone 020 7608 4100 www.arts.orguk/londonarts.

The views expressed in this publication are not necessarily those of the Editors or Publishers

Design by Declan Buckley Printed by SpiderWeb.

In April 1999, the symposium 'Out of the Bubble' brought to Central Saint Martins educators, practitioners and students intent on examining the issues within contextual visual arts practices and their implications for the preparation of Fine Art students for practice as professional artists. Presentations from international curators, artists and educators testified to the expansion of artists' practices which engage with social and environmental issues and their impact on Fine Art education. Pinning down the strategies and tactics of arts practices located in spheres which relate to far more than the mainstream metropolitan art worlds is like shooting at a moving target. The promise of change and innovation embedded within and responsive to the subcultures of our society, the very element which is exciting, carries an inherent risk, paradoxically, since it militates against inclusion on its own terms and recognition by the slow-moving behemoths of institutions of arts education. We are dealing with problems of assimilation and an inherent conservatism.

These problems are felt globally. Interviewed in 1998 for AN magazine, Carol Becker and Suzanne Lacy both established American educators and advocates for the instrumentality of art in social change, discussed two distinct strategies to bring about institutional change in the values and aspirations embedded within the conventional models of the Fine Art curriculum. Becker's approach was softly softly using a long-term approach of integration. She had reached a position within the institution to introduce courses delivered by experts whose reputation would attract students, whilst creating opportunities for students to make decisions and initiate projects collectively. Lacy, on the other hand, had established a new school with a mission statement dedicated to 'service-learning', emphasising the importance of learning of communication skills both visual and linguistic and the development of critical faculties over the specialisation within artistic disciplines.

Such strategies, albeit from an American perspective developed from a different history, succinctly express the tensions within the relationship between contextual practices and established Fine Art education. Underlying that relationship is the tricky historical relationship between British community-orientated practices and the institutions of culture and the persistent perception of such practices as being somehow inferior. The 'Out of the Bubble' symposium was engendered through the establishment of a Contextual Practices network between fourteen art schools which had introduced contextual practices into elements of their curriculum, either as modules or autonomous courses. Its members met to compare their experiences of introducing new teaching practices, such as placements, into established curricula. These educators are themselves practitioners, engaging daily with such complex issues as the artist's ethical stance towards participation and its political implications, the relationship of artist to 'audience' and the constituents

of 'audience', the concept of 'context', the appropriateness of a Modernist aesthetic language for artists working in hospitals, churches, schools, prisons and beyond. In forming the Contextual Practice Network, they have recognised, as educators, that the Fine Art education system fails students who graduate without having first addressed at least some of these issues directly in their own practice.

Inextricably interlinked with these ethical issues is the question of how best to teach issues of professionalism regardless of whether students choose ultimately to engage with practices aiming to bring about social change. Students need to learn, alongside aesthetic sensibility and production skills, collaborative working, project and time management, promotion and marketing, an understanding of the arts funding system and the confidence to initiate opportunities as entrepreneurs. The art education system has an obligation to inform students fully about the realities of how artists exist and make a living in all sorts of ways at all sorts of levels, beyond the model of 'art star'. Presenting models rooted in reality is not about killing an aspiration for a particular kind of recognition but about encouraging students to meet their personal aspirations, by teaching them not just how to think art and make art, but how to understand and deal with the contexts for its reception.

Seeing arts practice as a profession and as a way of life demands new methodologies in arts education to prepare students effectively. There is no magic solution, no *single* template for the effective delivery of a professional practice element within visual arts education as is shown by the range of approaches currently used by Fine Art courses in Britain. Used singly or in combination, methods include lectures by teaching staff, visiting speakers, individual tutorials, group seminars, internal and external projects and placements. Some colleges organise special events or conventions combining lectures and presentations with discussions and advice sessions. Although these methods are effective in conveying information and focusing minds for a concentrated period of time, information concerning professional practice is often delivered towards the end of the course - too late for many students to act effectively on the advice or information before being cast adrift after the Degree Show.

Experience, research and enquiry within Fine Art education indicate that one approach consistently seems to 'work'. Learning by doing in 'real-world' contexts through students regularly undertaking actual projects outside the walls of an art college whilst supported by its learning environment, is a highly effective means of learning contextual and professional issues over and above lectures, visitors, presentations and manuals. Even if live projects sometimes do not meet their initial aims and objectives, what has been learned can still be extremely valuable. However, for maximum effect, models of contextual practices and professional practice need to be integrated within the Fine Art curriculum from the very beginning of a student's education, and furthermore, the most appropriate teaching/learning methodology for their delivery is primarily *experiential*.

The intention of 'Out of the Bubble'

5

symposium was to bring together artists, curators and art educators and students experienced in various forms of contextual practice to compare professional and educational strategies, to learn from each other, to debate differences constructively and to create an inspirational forum for new initiatives. Delegates at 'Out of the Bubble' generated several days of intense excitement and heated debate in discussions chaired expertly by David Harding and Susan Jones. It is not possible here to reproduce the experience of the symposium in its entirety such as the exhibition of students' placements and external project work from the B.A. Fine Art Course at Central Saint Martins, the opening performance by Richard Layzell, the flow of discussion and all the images presented by speakers. However, the edited transcripts and essays included in this publication stand as a record which captures a selective snapshot of the tactics, strategies and manoeuvres practised in April 1999 and serve as a marker in the ongoing development of teaching and learning practices within Fine Art Contextual Practice.

TACTICS

John Kindness

Keith Khan

Edwina fitzPatrick

Adam Chodzko

Alison Marchant

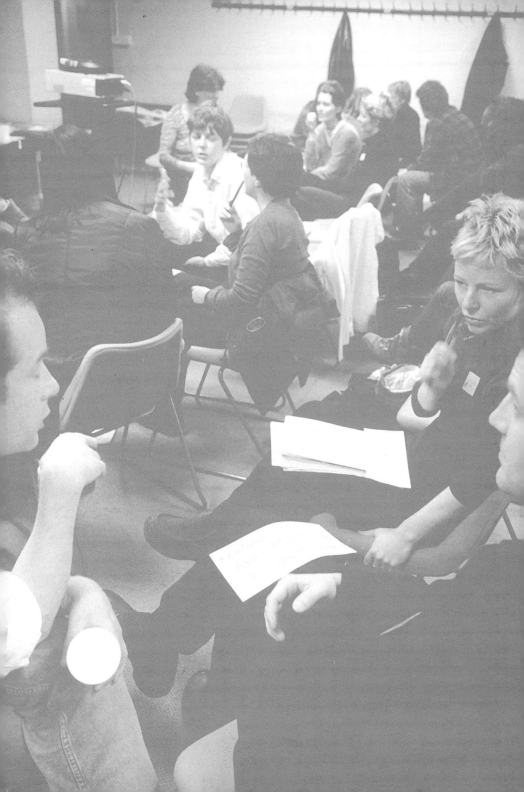

[John Kindness]

MAKING ART
IN A HOSTILE
ENVIRONMENT

I have been working full time as an artist since the mid-1980s. I am going to talk about ways that I have tried to create a constituency for myself as an artist in a society that did not have a place for artists when I was beginning my career. The place is Belfast: the city where I grew up, was educated and went to art school, and where I first started to make art in public arena. I have worked inside and outside the gallery context. Most of the work has happened outside the commercial gallery system although I have worked with commercial galleries on various projects.

I used to do some television graphics and some commercial design work to earn a living. I decided at a certain point that I could not really follow my career choice properly if I was compromising with other stuff so I stopped doing that kind of work all together in 1986 and started making art full time. I got some work into a show in New York. Some pieces sold in a summer show. I won some money from an annual arts award from an Irish company. Little bits of things contributed to an income. I remember people asking me, "Why are you doing this? Are you going to be able to survive?" It took about five years before I returned to the level of income that I gave up to make the art in the first place.

At that time, there was very little opportunity to sell work to any private collectors. For me, the most important thing was communicating with a public, getting through to an audience. Making the art and getting it seen. The first time I showed work in a public place in Belfast

was in a bank. I was talking to my bank manager about the problems that I was having with my chosen career path. He said, "We do exhibitions in the central headquarters of the bank" and he gave me the number. I was invited to do a show in the bank. There was this huge space and all it had was a few withdrawal slips. Nothing was going on in there. I was able to stage an exhibition. I actually made a piece of work in the bank during business hours. It was an opportunity just waiting to be used. The good thing I discovered about the bank was that I was on their territory. It was their bank. They did not have to cross a threshold into an art gallery and feel stupid because they did not understand the art. They were quite comfortable with the surroundings. I was the outsider. I think that made a huge difference to the dialogue. I was just talking to people all the time. People hover around the back and you know that they want to start a conversation. Eventually I just stopped working and would chat to them. My contention is that everybody is interested in art. They only think that they are not because they are put off by art that happens in a fairly rarified atmosphere or art that they see reported in tabloid newspapers, which seems willfully obscure or controversial.

This project was a series of works under the title: 'A monkey town besieged by dogs'. It is an Animal Farm-type satire on sectarian division and conflict and was shown in a non-profit-making space. The monkeys were Loyalists and the dogs were Republicans. In the images, the monkeys are in an Orange parade, marching with their banners and their instruments and the dogs are standing in front of an altarpiece with a crucified

'Newsprint' Octagon Gallery, Belfast and 50 sites throughout Northern Ireland. 1988

dog. It is as relevant now as when it was done in the mid-1980s. The series was comprised of fairly conventional looking works although they were drawn with chalks on sandpaper, which is a bit unusual. It looked like an exhibition in a gallery with works framed and hung on the walls. We tried to get as much information out there as possible. A screenprinted poster was put out and some T-shirts were produced using the central image which became a kind of logo for the show, to try and extend the information about the exhibition further afield.

Audience: Are you a monkey or a dog?

I am a mongrel, I think. My mother was a Humanist so I grew up without any form of religion but I went to a state school which was in effect a Protestant school because the Catholic church had its own educational system. I grew up in a Catholic area of Belfast though I did

not realise it when I was a child.

This was a proposal for a public commission at an airport. The formica cladding in the airport lounge would have been clawed away to reveal frescos as if they had been there from a previous incarnation. Although it wasn't used, I didn't want to jettison it so I continued to work on it as a series of twenty portable panels. It relates to images from my childhood, growing up in Belfast. They are now in the collection of the Ulster museum in Belfast.

One of the sequences in the frescos is about that discovery of the difference that there is in society. At first I thought it was to do with having your hair cut. Just that confusion of living with political posters and advertising signs and trying to make sense of something that was going on in society that I was not made aware of as a child. Belfast in the 1950s was relatively peaceful. There were no soldiers on the streets although the RUC did carry guns. When I asked my mother about this, she said it was in case a horse broke its leg and they needed to shoot it. Obviously she did not want to tell me the real reason why the police carried guns but I found out soon enough.

I think that it was important for me that I grew up without a sense of sectarian division. I was 17 or 18 years old before things really got difficult, before violence openly erupted on the streets so I had a long period of living in relative tranquility that formed my interests.

In the mid-1980s, I had the opportunity to create a piece of work in Central Belfast. In fact, it was a moveable location because it was on a bus. It was one of a series of opportunities, organised

11

by Art and Research Exchange, for artists to show art work in locations that were usually reserved for advertising such as panels and billboards, and on public transport.

I just went for the expectation that people would have of those spaces and made spoof advertising. The transport projects and the billboard were opportunities provided by someone organising an interventionist project involving various people. The 'Newsprint' project was something that I always wanted to do myself. I had always wanted to make a visual response to news events, working the way a journalist would work and get it out there into a public arena.

The idea was to work on a visual image on the same time scale as a newsgathering operation would operate. Just in the way a journalist would come onto a shift, I got up around 3.30a.m, cycled down to the newspaper office, got early editions, listened to broadcasts and tried to pick up what information I could about what news was breaking that day. I worked with imagery and met up with my screenprint technician about 6 a.m and by then I would have some ideas. We would start to put the image onto a screen. We had to have it printed by midday. The Belfast Telegraph, the major evening newspaper in the city, distributed the posters along with their paper to 50 sites. We had a special board ready with a hinge on the back of it so that the poster was just slotted into the board the way the headlines were on the regular newspaper boards. So a different poster each day was seen simultaneously in 50 places for about 10 days. I delivered the poster myself to a few of the sites in Belfast, which was a nice thing to do,

because I received direct feedback from the people that were viewing it. At first, many of the newsagents thought this was some kind of Belfast Telegraph promotion of which I was kind of glad because they weren't hostile to it. They began to get interested. Some started to keep all the images. Some people stuck them in the bin when they finished.

The poster covered the immediate news of the day; maybe something in politics, or a murder, or something prosaic about dog shit on the streets. I tried to cover the whole spectrum of news coverage. Within the first few days I was hoping that some awful tragedy would not occur because it would have been very difficult not to respond. I tried to be as inclusive as I could. The first story was about Jack Charlton, the manager of the Irish football team at the time when they made history beating England with an English manager. It was immensely popular. Not being a sports fan, I did not realise how popular it was. It got the project off to a very good start. Then people were more prepared to accept other ones with a more difficult message which might have caused offence. Sacrilege always causes offence. The image of the altarpiece with the dog being crucified, people were offended by that. But Northern Ireland has a high proportion of church-going people who take their religion very seriously.

Audience: Do you use humour as a way of accessing things in terms of Belfast and the very sensitive societies there?

Humour is a very important element in Belfast culture; a very important survival mechanism for people suffering a lot of hardship and grief. There is a toughness about the Belfast people but

there is a sentimentality underneath that. I think humour is the thing that bridges the two. It allows people to retain their humanity but keep on going in the face of a lot of discouragement. It is certainly important to me. In the days when political unrest really took a hold and Belfast was crippled as a living city, I was involved with a group of cartoonists and we produced the Belfast People's Comic, which was a satirical publication. We made fun of a lot of the divisions that some people were killing each other over. We had no illusions that this was going to change the society that we lived in. It was keeping us sane and creative during a very difficult time. I remember I did a strip on how to tell the difference between Catholics and Protestants. Some people were offended by bits of that.

There is a lot of art in Belfast that is extremely partisan. There is a tradition of Loyalist wall murals commemorating Protestant milestones in history. During the hunger strikes of 1970s there was a big resurgence in Republican wall murals with very strong visual imagery where they were fighting with every weapon that they could. Some artists and art students have been involved in designing the murals in both communities but most artists I know find it impossible to align themselves with one side or the other. There are very few artists who are prepared to take sides in the political struggle. I just could not be anything other than neutral in the context of the way that I was brought up.

The evidence for a divided society is subtle. The obvious things that the kerbstones are painted red, white and blue in one district and green, white and gold in another. Somebody from Mars or Minnesota might think that the people in Belfast just like to paint their kerbstones. A lot of the differences are extremely subtle and working class Belfast looks pretty much the same whether you are Protestant or Catholic, Republican or Loyalist.

The word 'sculpture' was not in my vocabulary when I was growing up. The

13

Billboard Project, 'Kindness' catalogue, Douglas Hyde Gallery, Dublin 1990

only sculpture I was aware of as a child was the statuary around the city hall but I was aware of a lot of things that were sculptural in their nature. Our mother named our teddy bears and would sit for hours stitching these things, trying to get the expression right. It was a sculptural activity though she would not have called it that. When you went into an elderly aunt's, there was always a china cabinet in the 'good' room, full of little polished ceramic souvenirs from different places or ornaments or birds. I know I was fascinated by peering into those kinds of things as a child. Those are the sculptures I grew up with. Those are what probably formed my sensitivity to three dimensional forms and colours and representation of animals and figures. It is part of a vernacular tradition of appreciation of those things in a society where there really was not much art about.

As a series of commissioned works for a children's hospital, I created the museum of 'The Old Lady who swallowed a Fly' with an alternative china cabinet of the eight animals she swallowed plus a lot of her artefacts. I worked with other makers: a lace-maker, a potter, a knitwear designer, a silversmith, to make her belongings such as her bed-jacket, her lace collar and cuffs and her tea set. Apart from insects there are little bits of newspaper and computer chips and various 20th century things, cast in resin. The idea of the Old Lady's china cabinet was that it was that her ornaments had got mixed up like genetically modified ceramic ornaments.

The Old Lady who swallowed a fly became a real person. I tried to make her into a real person. Doreen, the lady who posed for the photograph was a little bit of an archetype and became a model for this old lady. Doreen had a food cupboard with what I used to call her antique food. I once found a packet of tea with its price in old money. She recently went to a nursing home and my wife helped her daughter to clear out the preserves cupboard. There was mummified jam in there from 1954. Doreen had these old amber necklaces. She helped me to visualize or mythologise the Old Lady who swallowed the fly. It does have a significance to actual life. It is not pure fantasy.

Audience: Have you used cultural stories like the Old Lady who swallowed the fly to tell other stories about your society or the culture?

I made the piece almost subconsciously. I was thinking about all

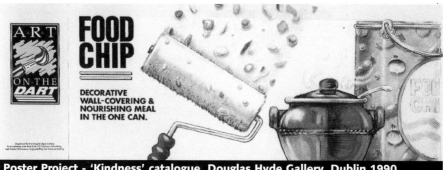

Poster Project - 'Kindness' catalogue, Douglas Hyde Gallery, Dublin 1990

14

the elements that the Old Lady had swallowed and I was thinking: Was there a psychological metaphor of swallowing an inedible truth, or swallowing hurt or pain over the years and not being able to digest it and it coming back and eventually killing you?

Audience: I was puzzled by the art you have made. It is so domestic and to do with that home history. It is not what I expected. It is kind of untouched almost. It is cosy art. That is why I got this intense family, domestic feeling from it.

Lucy Lippard, an American critic, visited Belfast in the early 80s and wrote an article for an Irish magazine 'Circa' on her visit. This was my response to her letter. It sums up what I felt at that time about the role of the artist in the society of Northern Ireland. When I reread it, I still feel those things:

"Ms Lippard suggests that neutrality is possibly the most radical position to take in this context. I don't know if it is a very radical position but it certainly takes a deal of courage and patience to maintain sometimes. It is not any military presence that keeps the social fabric of this community from disintegrating but the army of people, thankfully now increasing, who paint, write, play music, open restaurants, run nightclubs and generally struggle to keep things going here, that are merely taken for granted in London and New York. Sitting on the fence used to be a popular derogatory description of such neutrality. Sitting in the fence would now be much more appropriate as it is only a large body of positively charged people that will continue to keep warring factions apart by refusing to accept that their cities have become nothing more than

battlegrounds. In most cities, normality is a humdrum condition which artists would try to transcend. In Belfast and Derry it is a privileged state that we must make the best of for the short time that it usually lasts.

As the Troubles are the only aspect of our society that the rest of the world seems interested in, it may be tempting to package and sell them as many of our playwrights have done. But to me it is an insult to a very rich and curious culture to have only its negative and destructive elements highlighted. I'm not saying however that violence is too hot a potato for sensitive artists to handle, far from it, but we need to be able to tackle it in our own good time and to treat the subject with the insight of a native and not the sensationalism of the media vultures." Does that answer your question?

I try not to make a distinction between public art and personal art, private art. To me it is in the public domain anyway. When I am making work, I have got a very wide audience in mind for it. That is the audience that I want to communicate with and the channel that the work goes through sometimes is irrelevant. By a twist of fate the 'Belfast Frescoes', originally proposed for an airport commission which did not happen, were sold in a commercial gallery and then found their way into a public collection in the Ulster Museum, a museum that has a full spectrum audience. It is not just an art museum. That mindset of having to make one type of art as a public commission and another type of art as a personal statement can be eroded considerably. We make too much of a distinction between those two things.

15

Projects presented at conference

'A Monkey Town Besieged by Dogs', Grapevine
Arts Centre, Dublin, Orchard Gallery, Derry, Third
Eye Centre, Glasgow 1984 - 1985

Billboard & Public Transport Projects - see
'Kindness' catalogue, Douglas Hyde Gallery,
Dublin 1990

'Newsprint' Octagon Gallery, Belfast and 50 sites
throughout Northern Ireland. 1988

'Belfast People's Comic' may be available from the
Linenhall Library, Belfast

'The Museum of the Old Lady Who Swallowed a
Fly' is now installed in the Children's Hospital at
the Royal Victoria Hospital, Belfast.

'Belfast Frescoes' permanent collection, Ulster
Museum. Publication available.

[Keith Khan]

GAMES
WE PLAY

I shall start with some images that work as a metaphor for the games that we play in order to be artists. Today I shall use this photograph of the model, Alek Wek (taken from a fashion editorial) to present an image of the artist because much about this image is problematic. I am very interested in the whole idea of coercion and the effect of external pressures on the artist: how little control the artist has on things around them.

Alek Wek is from the Sudan. She is the most overtly African-looking woman to have lasted in the European fashion world for a long time. The interest in her is partly to do with her looks and partly to do with her positioning. Did she, in these images, have any choice about being in a sexualised pose? In this image, she looks particularly like a Hottentot Venus with a big arse and big breasts. What were her options? The way that the photograph has been treated, the fact that she appears to look half drugged, the fact that she is semi-naked; how much of this was in her control? How coerced was she in the making of imagery that uses 'villagey' African references, even though, ironically, she is wearing Alexander McQueen and Chanel? I am also showing these images because I think that they have been styled possibly by a black stylist. These are Givenchy shoes, strappy, expensive shoes on unstockinged legs, straight out of the village hut. Everything about her is over-emphatic, over-scaled. You do not see white models photographed in that way. This image overtly refers to Josephine Baker in the style of the photography which emphasises her blackness in every

way possible. I find them really difficult images in all kinds of ways. They do not come by accident. There is a whole layer of debate about the control of the photographer's eye and the complicit nature of the model's role within this. Is she using it to her advantage? Is she empowering herself by her complicity? I think that there is a double game going on.

Issues of control, complicity and manipulation link these images with the role of the artist since I think artists very often have to play a similar game and are part of a bigger picture. My image of the artist is of someone who perhaps has very little control about how they are placed in what they are doing and how they are viewed. In terms of the work that I have made, my chosen art form is complicated and the language about it is made more complicated by external pressures over which I have no control. The other similarity between Alek Wek and artists is that she has a limited span in terms of how long she will be fashionable. That is also true for artists, they come and they go, when no longer relevant.

Artists are very good at avoiding definition. In terms of art form genre, I do not really have a neat title to describe my art practice since it has changed over time, reflecting that it is possible to do different things without having to be defined. My partner, Ali Zaidi and I made ourselves into a company, Moti Roti, so that we became eligible for funding after doing a project together as artists. We were able to get lottery funding from the Arts Council for a fixed term period of three years. Significantly, the Arts Council press release announcing the lottery awards listed each organisation by name, description and art form such as theatre, drama, visual arts.

Our description simply stated 'Asian arts' even though the phrase is meaningless and is not an 'artform'. It makes you question whether you are simply a cog in a particular wheel of racial or gender politics. Are we being used? And then: Are we happy to go to bed with those people? That is the reality of being an artist. Significantly too, the Arts Council press release used the word 'Asian' eleven times in the four lines describing the project, although we mentioned it in passing in our application. I find such overstatement really offensive. The work is about contemporary practice. It is not about cultural identity though it is obviously informed by cultural identity. The bigger picture that cannot be ignored is the fact that artists have to work in the market place. As artists, we have a responsibility to reflect economic shifts in society. I find it fascinating that although we now recognise that 25% of London is non-white, I have trouble finding any representation of that proportion. It is still a very mono-cultural society, reinforced by the education system. People's inability to change and inability to want to change is one of the major causes of mono-culturalism. It will be fascinating to see the repercussions of the Stephen Lawrence inquiry across everything from the police service to the education system.

I also think it is fascinating that there is very little written critical analysis about the work that we have done. It appears to be invisible. I think this is due partly to the issue of cultural diversity, which people find frightening, and also the difficulty in categorising our art form. Although several projects have been reported in the Guardian, the level of critical debate is limited to noting the visual impact. People

have difficulty in engaging with the combined arts sector.

The project 'Wigs of Wonderment' was originally commissioned by the Live Arts department at the ICA. It is basically a sensory journey centred around the body, using the body as source material. The project arose from the thinking about the placing of the work and looked at issues surrounding perceptions of black beauty and the lengths people go to in manipulating themselves in the search of beauty. The ICA has a very specific arts-based audience that understands what it is coming to see. The interesting question was how to make a piece of issue-based, non-confrontational, embracing work that is appropriate for that context?

The premise of 'Wigs of Wonderment' was basically that each visitor to the installation would meet nine people (artists and performers) one-to-one who would talk to them about the way they looked. The people involved in the piece were four women and one Asian cross-dresser. You came into the space and met with people who tried on wigs. You walked around the space, arranged with off the shelf beauty products, mostly for skin lightening or hair straightening. You met these people and you talked to them. You tried on some perfume and some makeup and at the end of it you got a head massage from Ali and myself.

It was very interesting dealing with people individually on such a small scale. It was also very expensive to stage because the numbers, in terms of audience, that could go through the process is very low and engagement is very, very high. We had to have lengthy debriefing sessions with all the performers afterwards. Within those conversations, so much more came up

19

about men and their inability to deal with their feminine side than it did about racial politics. It was really interesting that the project's initial aim was to explore issues of race/identity but the experience raised issues of gender/identity.

The basis for 'The Seed, The Root', devised by Ali Zaidi, was a gentle way of trying to make work that was relevant to a group of people who live and work in the Brick Lane area. It was very much about the dialogue and the invisibility of those people. Invisibility and subtlety was very important to us as we did not want to repeat the clumsiness of previous artists in the Edge project of 1992, where a group of artists had tried to work in the neighbourhood of Shoreditch. There appeared to be an insensitivity and a carelessness about the curatorial control of that project. So we wanted to do a project that was not overt and was very quiet.

The project emerged because we had made a very short animation film for Carlton TV about food. The fact is that 'Indian' food served in Brick Lane is a

fiction since it is designed for city workers to taste allegedly authentic food. There are five sauces in which you put different types of meat. It has nothing to do with either Indian or Bangladeshi food. The vegetables on sale in Brick Lane cannot be eaten in Brick Lane restaurants. Who are they for? The project was a discussion between restaurateurs. It manifested itself in one restaurant where we got the manager's mother and wife to cook the food they would eat. We then developed an alternative menu which is still available in that restaurant. It was a very subtle project; we basically ate our way through this alternative menu as a piece of work. Ali also hung a series of his photographs of vegetables as erotic objects as a pastiche of very kitsch erotic paintings already on display in the restaurant. The waiters objected saying that the images were too sexual.

There were also other things that were completely invisible to an outsider. We photographed people living and working in the area and printed their faces on a sari length and cushions that were placed into a sari shop. No one understood that the design on the border included the faces of kids, their mothers and the cooks and everyone involved in the project. There were little things placed in the neighbourhood that people living there would see and understand.

My background is actually in designing costumes for the Notting Hill Carnival. It was great just making work for the street because it is a completely different relationship A lot of the work has been engendered from the belief that it is crucial that we, as artists, have some kind of responsibility to our audience. The street is the site of the responsibility. I stopped

Keith Khan - Flying Costumes, Floating Tombs 1991

working when I started to ask: What does it mean? What is the perception of this work on the street, apart from it being a social phenomenon? What is the relationship between the performers and the audience? Unless someone writes something serious on the significance of Carnival, people will not know that carnival came from a subversive tradition. It has ended up being about prettiness on the street, in rip-stop nylon and size. The fact is that there are two carnivals. On one hand you have got the Trinidadian circuit that goes around the edge with the steel bands and forty-six costume bands. On the inner edge you have got sound systems with a different, younger generation who have a different relationship to the street. Basically the majority of bands in Carnival are predominantly run by black sisters, probably of Trinidadian descent, who work in nursing homes. In effect, Carnival is supported by the National Health Service. The nurses are the backbone which holds it together.

A body of work is designed for a specific place at a particular moment, the August Bank Holiday, when it is relevant and appropriate. On the streets of Notting Hill, you can see the dynamic between the performer and the audience. People are interested because people want to see lots of black people jumping up and down in pretty costumes. What happens when you take Carnival out and put it somewhere like Canary Wharf? We were paid a lot of money to go to Canary Wharf with ninety masqueraders. The experience was fascinating because it came at the time when Docklands was just being built and there was no audience, no one there to see them, at all. The whole thing was video'd from the Docklands Light Railway. I would

never do that job now. I feel that was a coercion. It was patronising and I do not want people to be used in that way. We were being used as the publicly accountable face of Canary Wharf. The displacing of the work into another context does not hold.

Again I took Carnival into another context, in the docks by the Arnolfini in Bristol for the project 'Flying Costumes, Floating Tombs'. At that stage in my career, I really wanted to make the world's tallest costume. It was 72 feet tall, suspended from cranes. It was commissioned by the Arnolfini and by LIFT, London International Festive Theatre. It started life as a costume but then ended up with a performative element.

Although three thousand people came on the opening day, I was very conscious of the apparent lack of diversity in the audience. Was this just a piece of cultural exotica? Even though I thought I had integrity and I thought I was making an interesting piece of work, the way it was viewed was not the way I wanted to present it. It was simply about spectacle. I did start from the perspective of an artist who has a personal vision, in my studio. But in the public eye, it becomes a different project. Now I would think more carefully about how it could be perceived, whether it was unintelligible to anyone else although it may look nice, in the same way Carnival can be.

In order to get different kinds of people to engage with the work, we made a film-based project, 'Moti Roti, Puttli Chunni' ('Thick Bread, Thin Veils'). The approach was to employ an Indian film star, who had played Krishna in 'Mahabarat', the world's biggest soap opera, and present the film in a venue

21

where people will feel comfortable along with a piece of live work. It was a trick which worked in many ways. We had created a mechanism to reach a completely different audience. They felt empowered and they could engage with the work. It is irrelevant whether you call the project an artwork because it was made in a theatrical setting with a theatrical presentation.

Although I have spoken about the body and I have spoken about the street, the gallery space is the only space that I have not spoken about. It is a hypersensitive space that is often under- or over-curated and the language that goes with galleries is really problematical. The debate between craft and art, what is art, when does art become art? When does it become fine art? In this context, the commission Ali Zaidi and I did with Walsall Museum and Art Gallery making large embroideries with a team of embroiderers in Pakistan would be considered a craft and therefore would have no critical value. I think that there is a real clumsiness about people's approach and understanding of what art could be.

Audience: You talked about your work being unintelligible. I don't think so. It meant something to those people. It might not mean exactly what it means to you. I don't understand why you would be dismissive of that.

I became aware of the difference between how the project was actually read and my expectation of how they would read it. I agree with you, people took a lot away from that project and really enjoyed it. That was good. But in retrospect, I would have distributed information which gave a background to the project but would not have told the audience how to interpret the event.

Audience: I wonder how you as an artist can go forward and can in some way determine your audience and this question of representation. Are there ways that you can ensure that?

I need to understand what the big picture is but I do not think a single artist can achieve that. Everyone should have access or points of access with work, particularly those who have historically been disallowed access to those institutions. I am saying that if there are ways that you can make work that are generous to everybody.

Audience: Could you speak about whether your art education has or has not equipped you for the work you have done later?

I went to Middlesex Polytechnic, now Middlesex University, to study Fine Art. It did not equip me very well at the time but retrospectively there was a lot of information that I was given that has been very useful. But it took four or five years out of the institution to recognise what had been said and how it was being told, for the penny to drop.

Projects presented at conference

1995 'The Seed, The Root' Brick Lane, London, London Arts Board, Arts Council (New Collaborations).

1995 ongoing 'Wigs of Wonderment' - an ICA (Live) commission at ICA, London and touring.

1993 'Moti Roti, Puttli Chunni' Theatre Royal Stratford and touring, funded by Theatre Royal Stratford, London International Festival Theatre, Baring Foundation, Hamlyn Foundation, Arts Council of England (International Initiatives).

1991 'Flying Costumes, Floating Tombs' Bristol (audience numbers 3000) and London (audience numbers 1200) an Arnolfini/LIFT commission with Westminster City Council and Artangel.

[Edwina fitzPatrick]

EXPLORING FEAR
AND LIBERATION

I want to discuss how two projects have impacted the ways I have subsequently chosen to develop, create and present artwork. 'Trust', a residency in industry organised by inIVA and two site-specific projects, 'Returning the Stolen Water' and 'Flow Chart', as part of the Ikon Gallery's 'In the City' programme

During these projects I had a sense that there were no hard and fast rules about how things should be approached, which was simultaneously liberating and terrifying. Whilst there are clear distinctions between a residency and a site-specific commission, the Ikon project quite consciously returned to issues and concerns raised through the inIVA 'Trust' residency, and there are huge overlaps between both works.

EXPECTATIONS

'Trust' took place over a six week period at three different chemical plants in 1997. As one of the first artists in the residency programme, I felt unclear about what was expected of me by the participating companies, and by inIVA. How would they respond to the research/artwork emerging, the form it might take, and whether the work was created on site considering that space was limited and security was an issue?

A tentative line of enquiry, that of working with the laboratories to develop stable combinations of seemingly unstable materials (notably oil and water), initially provided a safety net. However, since I had formulated it without direct knowledge of the site, it was swiftly vetoed as infeasible and insensitive to the site. I then had to acknowledge that the residency could only develop through a questioning of my own expectations, in terms of my existing working methods and previous assumptions about the sites and companies. Previous experience of having to create work for exhibition very short notice reminded me that I could use this time to relax and simply to follow ideas to see where they might lead. During this initial stage I visited all three sites, meeting employees in all areas, gaining insights into their production and storage processes; and how these chemicals are 'consumed' by us all.

A SENSE OF DISLOCATION

The diversity of the three sites, and my desire to find common factors between them led to a sense of dislocation. I also had to consider whether it would be more productive over such a relatively short period to focus on just one company. A lot of time was spent travelling on chronically unreliable public transport systems between sites; my accommodation there; and my home in London. This heightened the sense of dislocation; but paradoxically created thinking spaces. With hindsight, I realise that this space 'in between', in transit, was a key part of the residency, a thinking space, and a private realm when everything else felt so public. It marked the beginning of a questioning of how and where I wished to create my work; and whether the privacy of a studio, and the withdrawal it can offer was appropriate to me. I also became keenly aware that the artist's personality is a key factor for communication; and that their degree of comfort with this insider/ outsider role

strongly informs the residency's outcome.

THE ROLE OF RESEARCH

Having always created site-sensitive installations for gallery and non art designated spaces, the residency raised questions about the reflective process of making site-responsive artwork onsite at all stages of development. Issues emerged as questions such as:
- How do artists define the word research?
- What constitutes a finished piece, and to what extent is the completion of a work dictated by a deadline?
- Is there a line to be drawn between research and 'making'; and if so, where is it?

My feeling is that research is a place for true exploration: the area in which ideas/ the 'whatever may be created' are wonderfully amorphous and unfixed.

Ideally, research and artwork are virtually inseparable throughout the creation process. Concern over deadlines, and the need to create a finished piece can lead to a 'production line' methodology, with the 'blueprint' or idea being actualised with little developmental evolution of the original concept. A research-driven practice challenges this way of working, but is not unproblematic. Firstly, as each project evolves and as decision making becomes increasingly honed, it becomes self-limiting. Secondly, when developing and creating work 'in public', ideas are expressed verbally rather than visually. In the early stages, it is often very difficult to have an honest dialogue when you simply do not know where the project is headed.

THE APPROACH IN 'TRUST'

My approach was determined through the following observations:-

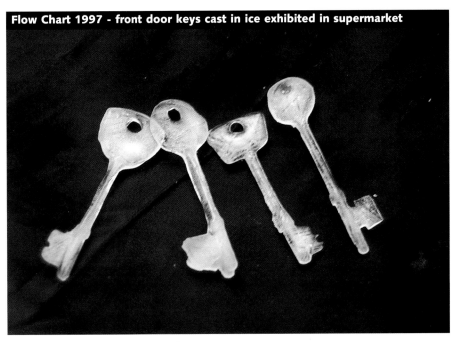

Flow Chart 1997 - front door keys cast in ice exhibited in supermarket

1. The sites could be perceived as bodies/metabolisms
2. The omnipresence of warning labels, health and safety measures, sirens etc. implied a sense of danger.
Volatile substances created a system of careful policing and regulation.
3. There was a preponderance of staff in administration. The plants themselves seemed virtually uninhabited, using technology run by a few key staff.
4. Pollution levels in the area and the high mortality rate meant that health and ecology were a local issue.
5. The Teeside chemical industry originated in urine processing to create cardinal red dye from local rocks.

Finally, I chose to invite fifteen people at each of the different companies to work with me, rather than treating the sites as abstract and disconnected entities. As such, the research/work took the form of discussions and questionnaires with people I had met on site, and others whom I met through them. Their responses to these interactions were condensed into hazard warning labels, which acted as (auto) biographies. They were then requested to donate urine samples as a physical biography of the individuals physical state at that moment in time. One company vetoed the donation of urine because this issue of testing was highly sensitive with their employees since they were randomly subjected to blood and urine tests. I found this veto curiously affirmative.

The installation was exhibited three times in entirely different forms, at the inIVA library and Middlesborough Art Gallery, and the inIVA retrospective at the Royal College of Art, London.

The residency informed my future

work in various ways. Whilst having been involved with previous residencies, 'Trust' created a starting point for a new methodology of practice, and enabled me to reflect upon my work in this arena. Issues were inevitably raised about the ethics of an artist working in collaboration with other people, especially about how the work is authored and presented. Taking the implications of this practice to its furthest limit suggested that the artist may be using or manipulating human beings as raw materials. When the collaborators are employees, is there space for them to stand back and question the artist's request? Is there a danger of coercion? Alternatively, could it be argued that this collaborative approach makes art less intimidating; and opens up a confidence in the creativity of the collaborator?

THE APPROACH TO 'RETURNING THE STOLEN WATER' AND 'FLOW CHART'

After seeing documentation of the 'Trust' project, the Touring Officer at the IKON Gallery, Birmingham, asked me to develop a project proposal as part of their 'In the City' programme. The remit to develop a project was incredibly broad. The three guidelines were that I should propose work that involved the Ladywood area near to the Ikon Gallery's new building in Brindley Place, that it was to be presented in a public context and that it was to be completed within six months to coincide with the 'Process and Participation' conference. I had carte blanche in three visits over a period of eight weeks to develop a proposal in a city I scarcely knew.

Again, I felt both liberated at the possibilities, and fearful about the

commission deadlines leading to the 'production line' methodology. As it seemed unlikely that I would be commissioned without presenting a clear and well-formulated concept, it was vital for me that the proposal had an in-built element within which the project could evolve and develop organically. This emerged through any possible outcome(s) being developed as a direct result of people's participation or non-participation. The proposal was accepted and subsequently led to the 'Returning the Stolen Water' and 'Flow Chart' projects.

RESEARCH AND DEVELOPMENT

I spent almost half of the budgeted time in Birmingham preparing the way for and introducing the project to the various companies, organisations and individuals. Eventually about 150 people informed the project. I found in this way, people became enrolled into the project by other participants rather than by

myself which reduced any risk of coercion. It was crucial to locate the most appropriate contact person, and the help of the gallery with this was invaluable on several levels. The staff knew the area and had existing contacts with some community groups in Ladywood. Furthermore the kudos of a large gallery behind the project, in my opinion, definitely helped with initial approaches to large corporations, such as Tesco or British Waterways. As this project required an immense amount of research and development, the collaboration of the gallery staff meant that I had more time to experiment and research in other areas.

This time I approached the site/city with a completely open mind. I was pre-occupied with having been burgled for the fourth time in as many years and curious to see if inner city living was the same in Birmingham, but I was not attached to this as an approach.

The project developed through the

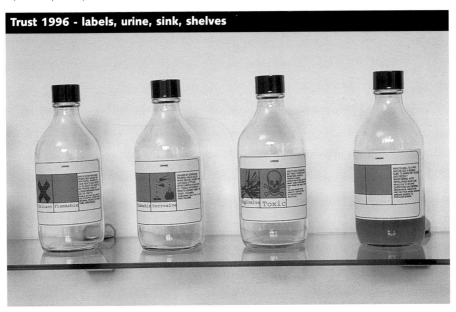

Trust 1996 - labels, urine, sink, shelves

following observations:-
- As the Venice of the Midlands, water was clearly an issue in the past and present development of the city; as was seepage and loss of water from canals.
- Birmingham was the first English city to supply piped drinking water.
- Birmingham has a history of metalworking and locksmiths.
- Ladywood perceived as multi-racial inner city area with high crime/ unemployment rate. It is also a long-standing 'community' with many people never moving from the area.
- What do we understand by the word 'community'? Would it be better understood if it were treated as a verb rather than a noun? Does a 'community' only exist briefly in time?

THE PROJECT

The project explored the notions of boundary and community from two perspectives: that of the threshold to a private space (the home), and that of a collective space (the City) using keys as both actualities and metaphors for these principles.

Working with different groups through shops, churches, and the community centre, all artwork took place onsite and included discussion, questionnaires and the casting of people's front door keys. At this stage I gave up differentiating between what I considered to be artwork or research.

By establishing who trusted someone else with, or was trusted with another's front door keys, a map of relationships emerged applicable solely to that area, at that moment in time. This work could never be shown anywhere else again, as it would become a dead monument instead

of a living 'map'. This trust may or may not reveal whether a community existed at that time. The silicone moulds of front door keys were cast as ice; and the overall flow chart of trust was presented in a full size freezer at the local Tesco store. Each person was represented by his or her keys and by quotes of their experience of living in the area. The freezer acted as a metaphor for the support systems that a sense of community can provide. Without the freezer, the keys melted way in less than a minute.

FEAR AND EXPECTATION

I found the ice keys extraordinary beautiful and fragile. They were difficult to install in the freezer. Like many installations, the actual set up period is the manifestation of a series of calculated risks, as the artist and viewer are both seeing the work develop in front of their eyes.

An initial screen which brought the keys nearer to the viewer had to be vetoed, as it set off the auto-defrost system. I then stripped all fittings from the cabinet when I realised, after spending two days and nights in the supermarket, that there is no greater anathema to retailing than an apparently empty display unit. However, there still were problems. Since the keys were extremely fine and delicate they were slowly being eroded by the auto-defrosting systems. This meant that instead of being in place for the full two weeks, the keys had to be re-cast every thirty six hours. This, in hindsight, was appropriate and added another layer of meaning to the work. However, it created disappointment because I had not delivered precisely what I had promised.

Tesco asked for the work to be withdrawn after eight days) and as such highlights the difference between a proposal and a promise, and between a concept and an actuality.

I realised that the artwork had existed as text/dialogue for the past six months. Over this time all participants, including myself, had unconsciously created a unique vision for ourselves of the 'finished' work. As such, 'Flow Chart' could never live up to this collective expectation but I feel did live up to the way it was created.

In contrast, 'Returning the Stolen Water' was a highly staged piece which very consciously took a different approach to the intimacy of the making of 'Flow Chart'. Created for the Worcester Bar in Gas Street Basin, at the heart of the canal renovation and tourist attractions, it involved a local actor performing a text written, with help from Ladywood residents, about the site's history and the loss of the keys to the city in the middle ages. The Worcester Bar was created because two canal companies accused each other of stealing their water: an issue still with resonance today. As such I stole water from the site, froze it, with the help of the IKON gallery staff into 100 large ice 'keys to the city', whose mould was taken from a key in a local lock museum. We re-released them into the Bar from a barge as a public event/performance coinciding with the conference.

BEING OUT THERE/BEING THERE

In conclusion, each project has raised as many questions as answers. Is it possible for an artist to cross the threshold between insider and outsider in such a short period of time? Do we as artists wish to remain distanced observers? I found it incredibly challenging to be 'out there', in public for so long - especially when locked into a freezer at minus 20 degrees, whilst the piece seemed to be going all 'wrong'. I even considered giving up this type of public practice. When working without a physical studio base, the artist literally becomes the centre for all creative production: interaction, research, and often creation of work, and the experience strongly authors what is created. This experience made me address and recognise the need for my own integrity; about being genuine instead of performing, as well as the requirement for others to recognise the vulnerability of my position.

I have also realised the importance of long term thinking on projects to avoid 'hit and run' experiences for artist and participants alike, especially after the project is visualised. A long-term perspective could enable the development of a different intensity, authenticity and understanding in all relationships as the project slowly unfolds. For example, 'Flow Chart' could have been conceived over several years and created door to door without any agency other than by word of mouth. It would have been very different as a result. However, it is important that agencies and major galleries authenticate, nurture and fund these large-scale projects, as it is difficult to set up similar projects outside the artist's locality without their support.

Finally, as this type of work exists mainly in the form of written proposal and dialogue through research and development, questions are inevitably

29

raised about the need to find a different art language, or even dispense with conventional art terms when working in residencies or offsite projects. Existing terms used throughout this paper seem inappropriate and unwieldy. Using a different terminology to describe our working processes could lead to de-mythologising artistic production, and thus slowly dispel notions of 'muse', 'inspiration', 'genius', 'bohemian' and 'general wasters of tax payers money', 'exclusivity' etc.

Ultimately, the nature of site/people-specifics is so diverse that no singular approach can ever be taken. As each project develops, I create new guidelines for my practice through being alive to my sense of liberation and fear at every moment. This creates new possibilities and helps me to grow as an individual/artist.

Projects presented at conference

'Trust' 1996. Middlesborough, Cleveland. inIVA Artist in Research at Tioxide Europe, Ellis and Everard and Phillips Petroleum U.K.
Exhibited at the inIVA library, London (1996); Middlesborough Art Gallery (1996) and Five years of inIVA, Royal College of Art, London (1999)
'Flow Chart' 1997 Tesco Supermarket, Ladywood, Birmingham
'Returning the Stolen Water' 1997. Gas Street Basin, Birmingham
Both commissioned by the Ikon Gallery as part of 'In the City' Programme

[Adam Chodzko]

OUT OF PLACE

I treat the making of an artwork as a certain kind of looking: the production of a vision within the public sphere. I see the public sphere as being networked by communication, desire, exchange and engagement. I see this network as being very flexible and constantly changing and contingent. Therefore it can be played with and transformed to propose new possibilities of space.

My art is not just about looking, but about looking for something; searching for something that is missing at present. This notion of 'looking for' takes place partly in the public sphere but also in interior space: the imagination of the inhabitants of that public sphere. As an example, a public space could simply be a network of people who all happened to dream two nights ago about a fox. They do not know each other nor do they know that each shared the same elements in a dream. After recognising the existence of this public space, a less literal notion of public space must also included; all the people whose dreams did not feature a fox.

The idea of 'looking for something' proposes an expansion of vision to accommodate that which we did not previously know or perhaps what we previously did not want to know. What are we looking for in the public sphere? As an example of an answer, I find it useful to go back to the first piece of art that I was conscious of liking - Brueghel's 'Fall of Icarus'. It is a painting of a public sphere. It appears to be an everyday pastoral scene, but becomes contaminated as soon as Icarus, in the form of barely perceptible legs sticking out of the sea, is spotted. Once the little legs are spotted, it absolutely transforms everything. The painting requires us to expand our looking, to expand our field of vision to let in something which should not be there, which is just on the edge of vision. Something should not be there either because it is lacking or else it does not already exist. I suppose what I am driving at here is that we need to acknowledge these flaws or glitches in the public sphere in art making, and in the way that we live our lives.

In thinking about art; these glitches or flaws, things which should not be there, become an aperture to looking within the public sphere. They may perhaps allow us to see briefly but clearly for a while. Walter Benjamin refers to this 'flaw' as a 'trace', when he explores the notion of detective stories, which equally connect to the idea of 'looking for something'. For Benjamin, detective stories are a cultural form that identifies ways of recovering an individual after their disappearance into the crowded populace of a newly industrialised society.

Ten years ago, when I first started making art consistently, I was very conscious of the difficulty of figuring out what to focus on. I was so aware of a plethora of information and imagery through advertising and the media in general, how could I possibly locate anything within it that seemed to be signalling to me? Again, it was this idea of looking for the thing that should not be there. Somehow the clue or the trace or the flaw was somewhere to look. To look for something that announced itself as not quite belonging. Around 1990, I started not only looking for these flaws

but also trying to place them into the public sphere. I began by doing extremely simple advertisements in classified advertising papers like 'Loot'. It was free to advertise. I would describe an object or a possibility that could not really exist. I began by describing art objects that I would quite like to make but were not feasible. Some were virtually meaningless, for example, 'millenarian heterogeneous apparition, unstructured model. Three meters long, with a slight defect', which I advertised in the scientific apparatus section. Basically it was describing nothing. The idea was to put art objects out into the public sphere to be encountered accidentally in the course of searching for something else, a coffee table, a car, a book etc. Instead of them being spectacular, they were just these small but very odd signals that you would stumble across.

An example of one method I use to play within public space is to introduce a flaw as a catalyst. I am going to show a series of flyers which I have been making since 1994. The first flyer was posted around central London, inviting people to attend an assembly. The idea was to have a convention of owners of a particular item of clothing. It specifically targeted people who had all bought the same jacket, made ten years earlier.

'Product Recall' (1994) uses the concept of 'product recall', the method whereby a company reclaims a defective product from the public space by making an announcement. The flyer treats 'recall' as a literal notion of bringing together something that has gone wrong, that is slightly flawed and plays upon the idea of recall as memory, a looping process, between the past and present. There is

also a strange, fairy tale element to the text in saying that it has been discovered that the design was based on 'an early scheme for a memory jacket'. It is not announced as being art. It simply is an odd thing hovering between advertising and I do not really know what else.

All the flyers show a contact number so that people for whom it seems to have meaning can get in touch. The flyers signal from quite a strange space, the periphery of public space. I see the notion of signalling as the communication of a kind of symptom. The thing that signals has to signal because it is concealed, because it should not be there. It is trying to communicate that we should listen. Using a model of psychoanalysis, things that are concealed are concealed partly through an unwillingness to acknowledge them and partly because they cause some sort of tension through difference and demand the necessity to acknowledge difference. The Freudian slip is a signal from another space into the public sphere that hints that everything is not as it seems. Perhaps too, this glitch or signalling is something that can be perceived as being 'ugly' in some way. A flaw is something that should not be there and so is associated with a notion of ugliness, a kind of awkwardness. Another example of such a flaw similar to that in 'Fall of Icarus' is in Antonioni's film 'Blow-up' where an existing photograph is contaminated by a thing that should not be there: a dead body perceived in the background.

Questioning where we look in the public sphere and how much we do not look into the margins of public space continues this idea of 'looking into the background'. This kind of marginal or

peripheral space is one I like using; on the edge of memory, something that is just about to disappear, or it could be on the edge of the city or the margins of society and the law. My work, 'Reunion; Salò' works with Pasolini's 1975 film, 'Salò or 120 Days of Sodom' where a group of sixteen adolescents, are killed in the fiction of that film. I went to Italy to find the eight girls and eight boys who had played them and to then stage a reunion of these people who appeared to have been killed in 1975. Again, on the poster I made for the retrieval campaign, there is a strange utopian claim, a naive hope which states 'Together we can create something new'.

I anticipated that I would succeed in finding at least some of the original 16 adolescents even after twenty-five years. The advertising and the publicity was extremely extensive around Italy so I thought that a lot of people would come forward. In the end there was only one person. She got in touch in the first week and then there was absolutely nothing. I began to feel that something had actually happened to the others. There was some reason why they did not appear in the present. Before she got on the train to return home, after participating in my film I asked her how she died in the film. You see one or two teenagers being killed off but the film is so heavily edited, no one is sure who has seen the least censored version. She said: "Oh no, I didn't die. The night before, I asked Pasolini if I could be excluded from taking part in the final scene." So she does not actually die in the fiction. So it suggests that the reason she is able to come forward twenty-five years later is because something was not resolved by not going

34

through this fictional death.

I try to listen to what is being said by things going out of control in my work. Then I try and steer the thing towards what this answer appears to be saying. Something is being said as a result of and in response to the search and I need to allow that to assert itself and to say what it wants to say. To stage the reunion, I decided to use doubles to make up for the missing adolescents. Obviously it felt as though something was wrong. As a result of asking a question in the public sphere, we had one person who is authentically from the original film but who had aged twenty-five years. You have a group of doubles who look exactly right but they are false. The 'Salò' reunion tried to make something visible and present which seemed to have disappeared through the fictional deaths of the people involved.

Through looking or through asking something that perhaps should not be asked, is the feeling that the response may seem out of control and excessive. To use a group of doubles and one original in staging the reunion was not the answer that I initially wanted. I always find a huge disparity between what I expect to happen and how the piece of artwork ends up. Usually there is a point in the middle where I am embarrassed and feel awkward about it because I think it has gone so out of control.

Asking the wrong question and therefore allowing it to go out of control is very important, as well as treating the loss of control as a medium or a message in itself. It is a playing with existing structures and remodelling of existing structures, whether those existing structures are films made twenty-five years ago or the fact that certain people

REUNION

Cerco i ragazzi che sono apparsi nel film *Salò* di Pier Paolo Pasolini (1975).
Seeking the children who appeared in the film *Salò* by Pier Paolo Pasolini (1975).

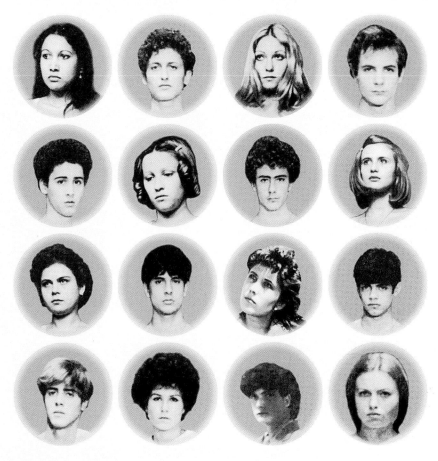

**Olga Andreis, Graziella Aniceto, Benedetta Gaetani, Dorit Henke, Faridah Malik, Giuliana Melis,
Renata Moar, Antinisca Nemour, Lamberto Book, Umberto Chessari, Claudio Cicchetti,
Gaspare Di Jenno, Sergio Fascetti, Franco Merli, Bruno Musso, Antonio Orlando.**

Insieme realizzeremo qualcosa di nuovo.
Together we can create something new.

Per qualunque informazione, contattare Adam Chodzko all'Accademia Britannica:
tel. 06 3230743 (lunedì-venerdì, ore 9.30-17) **fax** 06 3221201
e-mail bsrstu@librs6k.vatlib.it

might possess the same item of clothing. As an example of this method, the documentary film-maker Jean Rouche's film 'Chronicle of a Summer' (1961), uses the idea of looking as catalysing a form of reality rather than seeing reality as something fixed and external which you simply take a camera to. By looking, you transform something. Transformation has to be acknowledged in the final product. You are actually having an effect in the networks of the public sphere, as I said at the beginning. These networks are very flexible and change as result of every kind of intervention that you make in the public sphere.

Projects presented at conference
1990 ongoing, 'Transmitters', advertisements placed in 'Loot'.
1994 'Product Recall', video monitor, video projection and posters.
1997 'Reunion; Salò', poster, 12 photographs and video projection.
For further information please refer to:
1999 'Adam Chodzko', August publications. Texts by Jennifer Higgie and Michael Bracewell.
1996 James Roberts, "Adult Fun", frieze magazine, issue 31, p62-67.
1999 Interview with John Slyce, "Looking in the Wrong Place', Dazed & Confused magazine. August, no.57, p.100-106.

[Alison Marchant]

LIVING ROOM

I speak softly through a microphone, head down, eyes down on this following text, reading. I am sitting on a chair with a data projection, large scale, behind me - projecting pages from the CD-ROM of my book 'Living Room'.

Time is short, so I'm reading this. My 'Living Room' project is time-based. It is a work which was the result of a conceptual intervention with residents of the Holly Street Estate in Hackney, East London over four years from 1994-8. 'Living Room' was instigated with Holly Street Public Art and the resulting artist's bookwork was funded by The Arts Council First-Time Publications Scheme and published by Working Press.

I am interested in the sites specific, direct communication, representation and collaboration commencing with speaking to people who have direct experience of a place and situation where I am commissioned to work. Though this process I am able to gather data as a means of archiving the contemporary - which becomes an interesting paradox because the recording is always in the past.

Since Holly Street was undergoing a massive redevelopment scheme with resident participation this seemed a fitting context for discussion. The first redevelopment of Holly Street was in 1958 with the demolition of terrace houses replaced by high rise and low rise snake blocks. From 1993 demolition of these buildings begins. 'Living Room' tracks both these histories initially through recordings of interviews with residents then by having access to archive and family photographs, architects plans,

news cuttings and by photographing the estate myself between 1994-7 as an attempt to confirm the verbal information - fix it, hold it, catch it for a moment as it 'changes at a devastatingly fast pace'. Here community is a romantic notion which has long since been redeveloped. As I wandered through the hidden walk ways and the so-called 'dodgy areas' I realised I was mapping, and have always been doing that in one way or another.

In 1994 the arts organisation had just arrived on the estate and had little contact with the residents, and tried to approach them through newspaper adverts, flyers through their doors, discussions in the community centre, but there wasn't much interest. I was given a room in a flat in the estate with sound equipment. I thought I would just 'go for it'. So I stood outside on the street and spoke to passers-by about the project and they made appointments over 3 days - no one showed up. I thought - 'this is not going to happen'. The sound equipment hummed in anticipation. I went to the shops and chatted to people, then the laundrette, talking to people about this book and feeling such an idiot. After a while, individually people got interested. Individually people approached the mike knowing off spec what they wanted to say and said it. They are assertive - what they say concerns me in terms of reaction, I say this, I get: 'I don't care, I want it in the book'. I transcribe the tapes, they edit their individual piece. In 1998 we launch the book at Centreprise bookshop café on the edge of the estate and at Whitechapel Art Gallery. Everyone interviewed meets - sometimes they know each other, like/dislike each other.

Considering the book as an object and

installation space enabled me to design it with technical help. When placed back into the homes of the Holly Street residents the book is charged and sites specific, but the book also has the ability to be elsewhere in almost 500 places, including public libraries, and it has a certain permanence. The book also exists in its own space - social, conceptual and existential.

For this conference the actual pre-publication artwork is projected, and the sound tape is a sample of 6 of the 13 interviews. To open the book to a larger audience all at once I have to go back, rewind - into a kind of studio working state in a public forum; and the sound tape is also a sketch for a future work for CD digitised sound, currently crash edited, tape to tape. But the splicing of low tech and high tech also interests me because it is an abrasive merging where the immediacy of the initial recording contains all the breathing, movements, pauses, whispers and tape noise - another kind of personal space.

At the end of reading this text I turn on the tape player to my right, and walk to the back of the audience towards the computer where the technician has began operating it following my script - 'view' - 'go to' - 'page...' We speak together softly following my already mapped out instructions. We tap the computer key board 'navigating' through the computer pages as the monologue sound tape plays the sample interviews.

ANN WESTON
(Holly Street resident from 1948)

"Well, I'll start with Grange Court first of all. They did a lot of drilling on the site and we constantly had water spouting up in the air where they had found water. Apparently there is a tributary of the river Fleet which runs under Holly Street. Any way there was this water and they had to try something else, finally they did the pile driving for the tower blocks. Whilst they were doing this there was a constant thump, thump, thump. They used to shake the flats we were living in because they were building front and back, on Lomas court and Columbine Court, constantly there was constant shaking, if you stood at the kitchen sink and were beating something up, you just had to hold the fork really, it beat itself. You couldn't keep still through this. My husband was a long distanced lorry driver and after working nights, he used to have to stay at a friend's to get a night's sleep. During this time the council didn't used to tell us anything, we were given no compensation for all the upheaval we were put to - and no rent rebates which is common now. Also at the same time they were power drilling - that was going on in the day, and by night, Columbine Court which was on the opposite side of Holly Street, well, there was water in the lower part of that building. The River Fleet was underground and the water was constantly rising so we had pumps chugging away all through the night. Once again we got no compensation. I was quite amazed when they let Columbine Court and people took them. If they had known that those places were so damp, I don't know what would have happened. They have either managed to redirect the water or they have controlled it in some way because I never heard anything about it, but they were wet all the time they were being built.

Then heavy jacks came, they started

Columbine Court and although they had put the piles in, what they did was laid the floor, for the ground floor then they put a skin and laid another floor and a skin, till they had got all the floors they needed. Then these giant jacks came and they jacked them up into position. They constructed the levels for the flats and the snake area. Then the big work went up holding the flooring up. This was extra noise, and you had to walk about with earplugs in and you could still hear the noise. So the building of Holly Street - we've seen it all pulled down and we've seen it all go up. Now we are witnessing the pulling of it down once again, and it's my considered opinion that most of it didn't require pulling down, it needed refurbishing."

We've seen it all pulled down,
we've seen it all go up,
now we're witnessing the pulling of it down once again,
we've seen it all pulled down,
we've seen it all go up,
now we're witnessing the pulling of it down once again,
and if the council had kept up to their expectations,
it would have probably still been all right.

GEORGE WILLIAMS
(Holly Street resident from 1947)

"Well I just said, only the other night, must have been about 11 o'clock and there was this fella standing outside the pillarbox there and as I went by he followed me. So I thought to myself, what is he doing following me around, so I thought I'd lose him when I walk into the flat, but when I walked in he was still behind me, so I

turned on him and I said, what do you want, what are you after? And he was still behind me shaking, so I said to him, what's the matter with you? And he said "See them two fellas over the road by the pillarbox", I said "Yes", he said, "Well every time I made a move, they made a move, so I was frightened to move along, so that's why I followed you". I said to him "Where do you live?" He said "Up in the tall block". So I said "Come on I'll see you across the road, and you can make a run for it", but when I went, they had gone from the pillarbox. He was dead scared. I mean it's terrible. You can't go out without being frightened of something."

I mean, I mean,
that's why I turned on him I thought well it was him or me,
I thought to myself,
when he was right behind me,
I thought to myself this is then you better fight for you life now.
When he was right behind me I thought to myself,
you better fight for your life now,
that's why I turned on him,
I thought it was him or me.
So when he was right behind me I thought this is it then,
you've got to fight for your life now,
but it wasn't so.

CLARENCE DALEY
(Holly Street resident from 1970s)

"I want to remain in Holly Street. I love it down here, 20 odd years and I know everyone now. The only thing wrong they say is with the estate is that is was designed bad by having the corridor on the inside, if it was a thing that when you come along

here and you see a front door, then it would be lovely. Because if you see a person standing at your front door, you could see them from far, but you don't see anybody till when you got up, you see them at the front door and you can't get away if they are out to kill you, you can't get away. But other than that, every room, I go into, they say come in Mr. D have a cup of tea to my choice.

It's a shame to say that if the place was pulled down that only 30% will go into the new houses there. To know that a lot of who actually grew up together will move out, if they could be there too, then we will all be together. When the good time come, because we say this is the bad time and we have to put up with it, but when the good time come we should get a break. But according to them we are being kicked somewhere else.

Well I have a four bedroom here, two kids are away and two still here, big men but they want to be here. When the time come, I just want even a bedsit because they have to fight for themselves, see. I'm not worried about size, I just want a bed that is comfortable and a dining table because, for instance, I have a maisonette. When I come down in the morning, I go to the bathroom, I don't go up again till bedtime because I make downstairs so comfortable, a place to hang my coat, we have a toilet, we have a kitchen...I don't want to move out.

I want to stay here, I don't want to leave.... any hours of the night I get up walk around because even Tuesday night gone, I got up watching telly, I said "I'm tired now". I went down Queensbridge Road to Hackney Road, I went down three different sets of police cars, but they go their way and I go way. When I reach Shoreditch, I turn round and I come up Kingsland Road and I come back, and that was a good little walk. But I wasn't walking fast, just cruising and I came back in, have a cup of tea and go to my bed. I don't know if I can do that if I go somewhere else because I have to get used to the place and the people because I never carry weapons or nothing. The most I travel with is my cigarette, because I want to be free. Around here everybody know me, they attack anyone, but they don't attack me, but they know me and they respect me as I respect the old. So I want to be around."

So I want to be around,
I want to be around,
I want to be around.

NARENDRA PITHIA
(Holly Street resident from 1975)

"This is my first business in Holly Street. When I first came here, my first year, is really struggling with the business. This was a new area, new people and especially struggle with the teenagers around here. But after one year with police support, and good people on the estate, that slowly, slowly, gradually, I get in on the business and more and more I see the success side.

The teenagers, they come in the sweet shop, they are 15 or 16 and they try to nick things. I wonder why the people are like this with me, I am straight forward with them, why are they not straightforward with me?

The Hackney Council start to rebuild the new building of the whole estate. At least 7 or 8 estates completely demolished. That's why when the figure as an example, is like £100, now it is less than £50. Like a business completely halfway. We haven't

got anything like a passing trade, the council should do something about it, like rent and rates rebates, that is my main point now. We have kept our own solicitor altogether for the shopkeepers, but not completely satisfaction from the council at all - because so much money has been spent on the solicitor, it is expensive as well. But no responsibility has been met from Hackney Council at all, it is completely nil.

In this situation, you can't go forward and you can't go backwards, we are completely stuck in the middle. You can't sell your business because of the demolition programme.... You can't sell it or buy another business. Your money and everything, your life is still. What you've got in life is in the business.

A.M : Does the re-development scheme plan to build shops on the new estate?

No, they got a new development, they say they have got shops there. But the other shopkeepers and me included, we've never ever seen the plan. When you talk about it, many people, my customers and my relatives even, they say "You are really a fighter" and I say, "Yes, I'm a fighter. Whatever the condition, just go forward and I don't want to go away."

Yes, I'm a fighter,
f i g h t e r,
fighter.

MARY BECKLES
(Holly Street Resident from 1979)

"I mean kids could have actually gone out in the few play parks that we have got and play out there. I remember sort of playing games with the kids and the bike and sitting on the grass and you can't afford to do that now. It has basically gone downhill. I think it is lack of management to be honest.

Well ... if it goes the way we would like to see it, hopefully there will be better management. And theoretically there will be more flats and houses anyway, so, hopefully, each individual tenant will take more pride in basically the outside of their front house and back house whatever. I think that most of the kids that have grown up on the estate will take pride in it as well because they have lived with it. So they have seen how things have been over the years, so I think anything basically has to be better than what it is now. That's what I think personally anyway and I'm all for that. Improvement for everybody, old young whatever colour you are, especially the elderly, disabled you name it. I'm all for it.

I mean, I live on the 9th floor, okay, and when I come out to get the lift, I can see so much of what it was. If you look at it like say a year ago, it's completely different. Okay, everyone says that the houses are being built slowly, but it's a transformation. You know, when you think there were three sets of flats along there, it's hard to imagine especially if you haven't ever actually seen it from that height, I mean if you pass everyday or whatever, but it's going to look fantastic. I mean it doesn't look anything from the ground - you have to go up higher. So I actually went up to the 17th floor to have a peep out, even looks better from up there, I mean I'm scared of heights, but I thought I'm looking out of the window anyway, but it looks great from up there, but if they continue along those lines... I mean I know they have taken photos of the estate as it is now, and I think it will be great to see in the future, the now and the then, sort of thing. I think it will look nice from the plans I've seen but we

42

will have to see what happens.

Well, I've got a two bedroom flat and I've got a boy and a girl and I really need a three bedroom. They need their space and I need mine, that's obvious. I'm hoping, I'm hoping and that's a big hope - that I'm allocated a three bedroom house, I would dearly love a garden. I have been on the block too long and the kids have nowhere to play. My kids are scared of the lift and they won't go down in the lift, I have to bring them down and that sort of rubbish. That's what I would like personally, I wouldn't like to go into another flat, for the simple fact that when the kids are playing I have to shout, "Quiet someone lives downstairs", you know my lady bangs, this sort of thing. It's not really good for the kids, they need to play, I mean all kids they make noise at some stage or other, on the over hand if I get neighbours like the one I've got, I will be more than happy, yes, I'll be more than happy.

Hackney Council's not building any property really, you know, so...the majority of the property is housing association anyway. 75% housing association and 25% including the courtyard is Local Authority. Some tenants have opted to stay council, fair enough, a lot of elderly, well I say elderly, the over 55's want to go in Grange Court when it's refurbished. I've been to see some that have been refurbished and they look fantastic. If it all pays off, and I don't see why it can't work here the way it works on other estates that have actually not spent as much money and a bigger regeneration than we are doing.

I got a friend, she is a pensioner, she lives four floors below and she is 68 and it's hard for her. She has been on Holly Street from the time the building went up. For them now to be uprooting her at her time of life, you know she said she could really do without the move. But at the same time if she can find something that's comfortable for her, and she is not too far from the few friends she has got on the estate then all

43

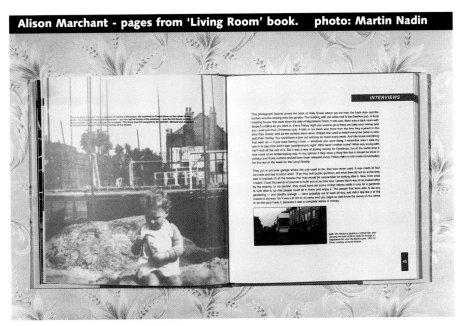

Alison Marchant - pages from 'Living Room' book. photo: Martin Nadin

well and good. Which is what we're trying to do, keep the community together, with those that want to stay, then why not, it's a good thing, it's better the devil you know. That's my opinion anyway."

That's my opinion anyway,
That's my opinion anyway,
That's my opinion anyway,
That's my opinion anyway.

AMANDA BUADI
(Holly Street resident from 1982)
& MARIA-MA NGOBAH
(Holly Street resident from 1983)

"There is a park, like across the road from here, and there is a park right outside my house when I go outside the building, that I go straight out to play on. There is a big hill and trees, then there's bricks around there and you can walk on the wall. Then the old people's home is there, and the park is there."

AM: You mentioned the adventure playground, can you describe it to me.

"Well you can come and go as you please and there is a lot of things you can do there...
You can go and come as you please. There is a lot of activities there like table tennis, football, skates, they let you use the skates for free... cooking, there's lots of games you can play.
On the side where you come in there's a big gate where you can get some honey from the bees. On the other side, on the left side there is this big bush with blackberries on and you should only pick the black ones because the red ones are a bit poisonous until they are ripe.
Also the are swings, and the slides are made of wood.

There used to be this dragon-slide made out of wood but they burnt it down because lots of kids were going down it at once and you could get splinters.
The swings are made out of tyres.
The frame is out of wood.
(Whispers - What was I going to say?)
We have bees and there is a pond with waterflies and lots of other animals. Like frogs and fish.
I live in the high rise tower blocks. I live on the 18th floor, second from the top.
I live at Silver Birch Court in the low rise buildings.
I'd like to live in a house with a garden and I think there should be more parks because when children go to parks it's mainly because they're bored and they want to do something.
And bored children usually turn to crime. Yeah, if they've got nothing to do."

AM : So Amanda has this estate changed while you've been her at all?

"Yeah, the house, the low rise tower block near the bridge, they've come down. Oak Court and Bruce Court have gone and now there's Welby Court and Sycamore Court, they've come down too, so the estate is changing. When it's all finished it will be all houses and one tower block, so it will be different."

AM : Do you think it is a good change?

"Well.... When we......if weif there's a younger generation we can't tell them where we lived because it won't be like that when we lived there anymore."

AM : And Maria-ma what do you think of the estate and the changes, and everything, what would you like?

'The new buildings like... it's like one house with lots of people living in it, it's like a flat, but I want to live in a house standing by itself, with a garden not just a big flat

with lots of people living in it.
And shops nearby.
And parks.
More parks.
When we lived in the flats upstairs I wanted a pet rabbit or gerbil and stuff, but my mum said that rabbits need a lot of space to run around in, so if we move to a new house and we have a garden they will get a rabbit or a pet for me.
And there's more space. You can play in your garden without going out of your house and you won't have any disturbance and if you have a bigger house you can have space to do what you want and you can have a pet and big parties and things you can't do in these houses.

AM : What do you think about Holly Street in relation to other estates in the Hackney area?

It's ok but it's a bit messy because there's dog mess and there's litter nearly everywhere.... and people do graffiti on the wall and there's gangs.
I haven't lived anywhere else so I can't really say that other estate are better than this one, or this estate is better than any other estate. But I like this estate because it's more interesting than the other estates.

because it's more interesting than the other estates.
because it's more interesting than the other estates.
because it's more interesting than the other estates.
because it's more interesting than the other estates.
because it's more interesting than the other estates.
because it's more interesting than the other estates.
because it's more interesting than the other estates.

because it's more interesting than the other estates.
because it's more interesting than the other estates.
because it's more interesting than the other estates.

I LIKE THIS ESTATE.

45

MANOEUVRES

Gerrie Van Noord - Artangel

Richard Hylton

Suzanne Oxenaar

James Marriott

& Jane Trowell - PLATFORM

[Gerrie Van Noord]

ARTANGEL - WORKING OUTSIDE THE WHITE BOX

Artangel was founded in 1985 with the aim of commissioning and supporting new public artworks in unusual locations. Its core remit was to collaborate with artists and curators from the start of the development of an idea, to the actual realisation of an artwork in trying to find new audiences, beyond the walls of the museum and the usual contemporary art exhibition spaces. Artangel was also founded to encourage artists working in a context of social and political intervention, who found it difficult to find a platform for their work within the usual frameworks. Furthermore, Artangel wanted to provide the same level of professional support and promotion to site-specific, unusual or more ephemeral works that was available for the presentation of contemporary artworks in museum or exhibition situations. In creating this new platform, Artangel sought to challenge and critique the more conventional art institutions and their curators. In the second half of the 1980s this resulted in collaborations with artists such as Barbara Kruger ('We don't need another hero', 1987 - a billboard project in 14 different locations throughout the UK), Jenny Holzer ('Messages' on a spectacolour screen in Piccadilly Circus, 1987) and Rasheed Araeen (billboard project 'The Golden Verses' 1990-1991).

In the beginning of the 1990s, James Lingwood and Michael Morris became directors of Artangel, and they established a slightly different approach. Rather than focus on works with a more political and interventionist nature, the main focus of Artangel shifted towards trying to create the opportunity and the conditions for artists to realise projects that, without Artangel, simply would not be possible. And rather than challenging the usual frameworks, its role was seen as complementary.

Unchanged is the central core of Artangel's way of working: to work as closely with the artists as possible, from the start of an idea, throughout the entire process of development, to its actual realisation. The starting point is always an open invitation, beginning with the question, "we're interested in your work, your attitude, can we talk?" If an artist says yes, a series of open-ended discussions follows. Initially there are no limitations; there are no requirements as to the nature of the work, or what medium it should be in, its size and scale, or when it should be ready. And although artists do not exactly get 'carte blanche', Artangel does not stipulate the size of a budget immediately either. It really starts with a mutual interest and a willingness to talk and to see what can develop. Ideas are read, tested, rejected, rethought and that process can take up months, or even years. Some projects have taken three, four, even five years to realise from the initial invitation.

Each project therefore starts with a clean slate. It may require new or unusual or complicated material manufacturing techniques that are not common in everyday arts practice. In that case, new ways have to be found, tried and tested. Sites and locations are researched. Sometimes the artist has and idea before a location is found; and once the location is found, it may steer the idea for the project into a hitherto unforeseen

direction. Or there may be a specific idea about the nature of a location for a project, which then has to be found and negotiated. Often ideas develop in parallel to finding an appropriate site. Over the years, Artangel projects have established a reputation of reacting to the historical, social and cultural history or background of a location or environment. They often make people aware of situations that they, in their day-to-day routine, take for granted or don't notice anymore. Then again, locations may not necessarily be physical, for example in the case of television and film productions, which Artangel has undertaken over recent years.

Once the realisation of an idea is on its way, it does not necessarily mean that everything is fixed. One of the characteristics of Artangel projects is that things only become certain, shortly before a project is actually going to take place or an installation is going to open. Once initial ideas take shape, Artangel uses technical assistance to get the project into gear and to provide whatever the actual project requires. Therefore Artangel staffing differs from project to project; the organisation expands and decreases in size in relation to the requirements of the projects.

One of the ever-recurring aspects in the realisation of projects is negotiation. Unusual locations involve negotiations with other parties, such as property owners, community organisations, local authorities, or commercial companies, to secure permissions for the use of spaces, locations or even temporary work sites, or to negotiate through the technical aspects of a works. In the case of very ambitious and large-scale projects, negotiations with collaborators are also necessary as well as with funding bodies. (Artangel receives core funding from the Arts Council of England and the London Arts Board.) Yet, in each situation, for

51

Gabriel Orozco - Empty Club June/July 1996 photo: Stephen White

each and every project, additional funding needs to be found, either from other funding bodies, from trusts and foundations, or through other means. Artangel has a group of private supporters, the Company of Angels, who support Artangel's programme. Over the years Artangel has been successful in negotiating sponsorship contracts with a variety of sponsors, such as Beck's Beer who have sponsored one project a year since 1993. In 1997 Artangel was awarded a National Lottery Grant in the A4E scheme. And there are collaborations with exhibition and theatre venues.

One of my aims today has been to emphasise the variety of visual arts projects that Artangel commissions. They vary in scale, duration, development time, and costs. However, many of Artangel's projects actually cross over into - or even start from - different fields like dance, music, theatre and the performing arts. At the core of Artangel's way of working is always the intention to realise projects without the restrictions of normal institutions, be it an exhibition space, a theatre, a dance studio or a concert hall.

The projects become complete once they are seen or experienced by an audience. Artangel has an extensive mailing list and we publicise projects as widely as possible once they are in their final stages. Artangel's policy has always been to hold back on publicity in the early stages of a project's development, in order to give the artists and the process as much room as possible and to avoid tying things down too specifically too early. Over the years, Artangel has built up a certain core audience. The nature and the variety of the projects encourages people who are mainly interested in visual art to go and see projects of a different nature, that are for instance rooted in performance or dance or music. So you get crossovers from audiences with a specific background and with each project

Matthew Barney - 'Cremaster 4', 1995. photo: Michael James O'Brien

William Forsythe, Dana Caspersen, Joel Ryan - Tight Roaring Circle, May 1997
photo: Matthew Antrobus

there is the hope that people with a main interest in a different field are tempted to see something they would not naturally have considered at first instance.

Projects vary in scale from the ambitious and monumental to small-scale events, which are accessible to a limited amount of people and last for a limited amount of time, such as the live sound mixes on a London bus which ran for three nights by sound artist 'Scanner'. At the other end of the scale are big enterprises like Ilya Kabakov's 'The Palace of Projects', which ran for 8 weeks, or Douglas Gordon's 'Feature Film', which involved the shooting of a feature-length film, and has different formats in which it is shown. In all its commissions, Artangel aims to push boundaries, either in the

negotiations with other organisations for the use of a site, or in challenging an artist to make new steps in his or her development, or in confronting an audience that may be used to certain work of a certain artist with something completely unexpected. Pushing boundaries and realising commissions off the beaten track, trying - in close collaboration with the artist - to realise things that in a normal context would not be possible because of limitations of time, space, and other factors; that is what Artangel was and is about.

Selected Artangel Projects Presented at Conference

1992 Stephan Balkenhol, 'Head of a Man, Figure of a Buoy', Head of a Man on pillars next to Blackfriars Bridge, Figure of a Buoy on a buoy in

the Thames, commissioned by Artangel and realised in the context of the exhibition 'Double Take', Hayward Gallery, London.

1993 Melanie Counsell, Coronet Cinema, a film installation in a disused cinema on Mile End Road, East London.

1993 Bethan Huws and the Bistritsa Babi, 'A song for the North Sea', performed on the North Sea shore in Northumberland.

October 1993 - January 1994 Rachel Whiteread, 'House', Mile End, cast of one of the last of a row of Victorian terraced houses in East London.

1995 Tatsuo Miyajima, 'Running Time/Clear Zero', installation and performance in the Queen's House in Greenwich, London, commissioned by Artangel and realised in collaboration with the National Maritime Museum.

1994 - 1995 Matthew Barney, 'Cremaster 4', filmed in 1994 and first presented in 1995, filmed on the Isle of Man, commissioned by Artangel and produced in collaboration with Barbara Gladstone Gallery, New York and the Fondation Cartier, Paris.

1995 Robert Wilson & Hans Peter Kuhn, H.G. A series of installations realised in the vaults of the former Clink Street Prison; theatre director and designer Wilson created this series of tableaux in collaboration with sound designer Kuhn and stage designer Michael Howells.

1996 Gabriel Orozco, 'Empty Club', a series of interventions and comments on certain aspects of English culture in the former gentlemen's club the Devonshire Club at 50 St. James's Street, London.

1997 William Forsythe, Dana Caspersen, Joel Ryan, 'Tight Roaring Castle', The Roundhouse, London; choreographer Forsythe and dancer Caspersen staged a gigantic bouncy castle in which the audience were the performers, with a soundscape created by Ryan.

1998 Ilya & Emilia Kabakov, 'The Palace of Projects', first presented in The Roundhouse in London, then shown in Manchester and in the Palacio de Cristal in Madrid. The gigantic snail-like structure contained 65 utopist projects.

1998 Richard Billingham, 'Fishtank', commissioned by Artangel and produced in collaboration with Illuminations, broadcast by BBC2.

[Richard Hylton]

SKETCH: SOME OBSERVATIONS ON THE POLITICS OF CURATING

I think it is useful to talk about some of the issues that have emerged for me over the past eight years through the projects I have produced, in terms of how my views have changed towards working as a curator and an artist. The three or four projects I want to discuss today are examples, which show how my ideas and attitudes have shifted from my first gallery job, then getting another job on a slightly higher level, and another job, on a higher level than that, getting more power/independence. There are two key things that have been important to the development of my particular way of working. Firstly, the opportunities and patronage that I have received such as an Arts Council Traineeship and secondly, the value in developing relationships with people, particularly, curators and artists. This second point is not about just about back scratching and 'using' one and other, but it is more about support and communication. The kinds of collaborations seem to have shifted, from working with big organisations to working with individual artists and individual curators in staging projects. These shifts and experiences are things that I have found quite fruitful.

I have a problem calling myself an artist because I probably do one show every two years. But I always keep that artist/curator identity on because I think that having to choose between being a curator or an artist is a rather conservative idea. It seems as though you must either be an artist or you must be a curator because doing both simultaneously, early on in your career, is

seen as not being a way of proceeding to becoming a successful artist. The reason that I use the term 'artist curator' is because I don't want to say, "I am an artist or I am a curator". But having said that, I suppose people see me more as a curator, and to be honest, curating has paid my way since college. So curating is the focus of this talk.

I studied at Exeter College of Art and Design between 1987 and 1990 and then went back to London with some alacrity. I was working part-time, portering and teaching photography in Adult Education, whilst thinking that I wanted to continue my practice as an artist. I saw an advert in the Guardian for Arts Council Traineeships, which were aimed towards people wanting to get experience of arts administration. I applied completely blind as to how the system worked. These traineeships were aimed specifically towards Black and Asian people, which was part of a strategy from the Arts Council of England, to develop the opportunities for Black and Asian people in Britain, not just in terms of being practitioners but also in terms of their relationship with institutions. Although I felt, and still do, that my own traineeship at the Laing Art Gallery in Newcastle was successful, you can judge the degree to which the scheme has been successful by looking around you today at the cultural demographics of the conference delegates. A lot is still to be done.

I worked as a trainee in Newcastle for a year and a half and then worked for three years as Exhibition Officer, responsible for the Outreach programme at the Oldham Art Gallery. It gave me the opportunity to research and become familiar with how arts organisations work.

My experience of working in the institutional context of a local authority has obviously informed the way I curate shows. Ideas for shows are compromised from the outset since they depend upon their context: whether it is a local authority-run gallery or if it is independent. In a local authority environment you have got the politics of what that gallery is supposed to do in a particular location and community.

I have adopted different ways of operating which have shaped the way I have developed as an artist-curator. All the administration and project management is, I suppose, an important process you have to go through, even if it can be quite tedious. Going away, meeting artists, discussing their work and

being in a different context helps break this monotony and helps to keep your enthusiasm about the actual show you're working on. I have been fortunate in that I have had the opportunity to travel to Pakistan, America and around Europe. It has been really good in terms of developing relationships with artists and in getting some space away from Britain and being able to concentrate on a project in hand. The pressure of being the administrator lifts slightly and you can talk about the show.

I think that there is a real mythology about galleries and artists. We buy into this whole system that artists who are exhibited, get shown on the merit of their work. You know this not the reality of how things work. A lot of shows come

Imagined Communities - Oldham Art Gallery 1996

about through artists sitting around coffee tables and that kind of thing. Often we are encouraged to think that there is one way of operating as artists: to get shows, to get on the treadmill and then rise rather than having a bit more reticence because in the long run that can be more productive for one's own practice. I think there could be a bit more reticence in terms of what artists do. Friends who are artists sometimes say, "The next show is going to be the show that will take me into a whole new lucrative profession." We are all trained to believe this.

Moving on from Oldham I have found it more valuable to move from bigger group shows to working with an individual artist or curator or curators who are artists or artists that might want to curate a one off show. I find that approach very interesting. I shall talk about these different projects to give you a candid view of working with organisations. 'Imagined Communities' was a collaboration with the National Touring department at the South Bank Centre in London. The idea of the show was to look specifically at the artistic community, at art itself, the art market, and the art world by juxtaposing artists based in Britain, Europe and America who were very much in the centre of the art world, with those who were emerging or weren't necessarily in that environment. We had people like Tim Rollins and the Kids of Survival alongside Christian Boltanski, Gary Simmons and the painter Denzil Forrester. I was conscious at the start of 'Imagined Communities' that the show could only happen if there was an institution involved in the show that could secure such things as loans from

private collections and galleries. The idea of working with the South Bank removed the show from the local authority context, where so much has to be put through a grinder of local authority politics to justify its relevance to the local community. What interested me was the fact that a municipal gallery in Oldham could work with this large institution.

I approached the South Bank because I knew that they had the resources to tour the show. But there is a price for that kind of approach. The price of entering a very high profile organisation is having to deal with their corporate desires or the corporate image they want to project and sustain for very legitimate reasons for them which, in turn, affects how the show was curated and the shape of the show itself. There were a lot of artists I wanted to include who weren't in the show. In terms of some of those famous artists, it wasn't conditional on them being able to get over to Britain. The South Bank's involvement meant that you had to fight for your curatorial voice in another way. That's how it is if you work with big institutions. Things have to make sense on the huge corporate scale. Where I work now at Bradford, it is a lot easier because it is just myself and an assistant. It seems to be more fluid. You don't have to go through different filters of validation.

Whilst doing 'Imagined Communities', I had varying degrees of dialogue with the artists, because some of the works included were to be loans, so they did not get involved. Most of attention went to Gillian Wearing and Yinka Shonibare whom we commissioned, whilst I also made 'studio' visits to Denzil Forrester and Tim Rollins & Kids of Survival, and had

meetings with Gary Simmons and one half of the Komar & Melamid partnership. I did not meet with the other artists since their dealers or lenders were the important link. In fact, I had more of a relationship with their collectors than I did with the artists. Some of the dealers were really straightforward, like Janet Green who is an owner of Selfridges and who lent The 'Scarlet Letter'. I dealt with her personal assistant. That work was in storage.

The show 'Tampered Surface' was produced in collaboration with the curator Alnoor Mitha who was working at the time in Huddersfield, and it was a complete contrast to 'Imagined Communities'. Previously, there had been several large group survey shows from Africa, South America and the Asian sub-continent, showing twenty or thirty artists. We wanted to get away from that and to show a small number of artists. The idea was to provide a platform for six Pakistani artists to produce new work and develop an international profile, without loading them down with being representatives of Pakistan. To present them simply with the privilege, as artists showing on the international circuit, like Saatchi's 'Young Americans'. These were artists who were already in quite close contact: four from Karachi, Durriya Kazi, Iftikhar Dadi, Sumaya Durrani and Samina Mansuri, and two from Quetta in the northwest of Pakistan, Liaqat Ali and Akram Dost Baloch. They each showed several pieces of work. It was basically an opportunity to introduce their work to a British audience. The work was crated and brought over by PIA, Pakistan's national airline, negotiated with the help of the artists in the show. They were very helpful

in a way that I would not expect of any artist in this community. It is a very different relationship with the artists from that of 'Imagined Communities'.

'Tampered Surface' heightened how local authority politics works. Producing a show like 'Tampered Surface' gave the impression that this show was specifically targeted at the Pakistani community in Oldham. We were very eager, in that context not to give that impression. This show was no more relevant to the Asian community, as far as I was concerned, than 'Imagined Communities' or any other show that we might do.

One of the problems with a show like this was to tour the show beyond the Midlands. Although it toured to Oldham, Huddersfield, Liverpool, Middlesborough, and eventually to Paris, we were keen to show this kind of show in London and the south in general in order to raise the profile of artists' work from the sub-continent. But it was very difficult to get access to galleries in London because of the nature of the way in which galleries work in London, since the ones that could be more flexible have no money. The ones that have loads of money are inflexible in terms of the kind of artists they show. I think it was a shame that it could not go any further. I think it says something quite instructive perhaps about our ability as administrators, and it also says something about the difficulty in getting visibility for these shows and the nature of the environment within which we are working.

In 1993, I wanted to commission a number of artists to make work on beer mats, which subsequently became the project 'Art under a Pint'. I had a very small budget so I approached Oldham's

59

Health Department on the advice of the Public Arts Officer, who had money to develop new ways of disseminating information about health issues in relation to alcohol. We advertised in two different magazines: 'Frieze' and 'Artists' Newsletter' (now AN Magazine). This small but important point indicates how wide we saw the project. If you advertise in one particular kind of magazine, then the responses you get will be of a particular type. The idea was to bring together two completely different entities since 'Artists Newsletter' deals with artists' professional issues and 'Frieze' is all about the so-called cutting edge. When we advertised, we distributed an information pack compiled with the help of the Health Authority and Oldham Art Gallery. Some artists submitted altruistic responses to the health issues. Other artists responded much more conceptually. From the responses, we aimed to select a number of artists to produce two or three designs for a beer mat, which we would then produce as a run of 100,000. It was interesting because the project brought together different kinds of artists like illustrators and more conceptual artists.

To get the beer mats placed in bars, there was a lot of dialogue between landlords and the Health Authority. A lot of landlords agreed because they were grateful to get them since nowadays a lot of pubs no longer use beer mats. By coincidence, an officer in the Council's economic development department was a member of Campaign for Real Ale and was enthusiastic about the project. He used to come and collect beer mats and then distribute them across the region at all his meetings.

The issue in this project was the nature of the collaboration with the Health Authority. We put all the shortlisted artists together. The Health Authority did not really like what they saw. All the stuff they liked, I did not like. It was quite a fraught meeting of two different agendas. As I said at the beginning, those kinds of things shape the way in which projects develop. For example, they did not want to approve the design by Charlie Homes, which read "Goodness is Good for you", since it clearly mimicked the Guinness advert, which was "Guinness is Good for you." So we had very heated debates and the politics of them shaped the project. I think the politics became more interesting than the project. This project was very different to 'Imagined Communities' or 'Tampered Surface' in terms of funding and profile. I think it has informed me in terms of how you work with organisations and the problems that you can have in working with big organisations to keep it going and to have some integrity for the artists or the idea of the project.

My practice has now shifted somewhat from working with organisations to mainly working with artists on an individual basis. For three years, I have been running Gallery II in the University of Bradford. What appealed to me about this job was that the gallery was quite new. It was also off the beaten track since it was a gallery in a science university without any art courses at all. This way of working enables me to work with artists in the space over a period of time, developing and creating a space for their work. Partly that is about the nature of the environment since I have responsibility for programming the space.

Tampered Surface - Sumaya Durrani, off set litho print, 1995

The price of such freedom is that the gallery is an anomaly within the university, although the university does have a theatre and a music centre. There is still a lot of work to be done in terms of developing the audience for the gallery, who are mainly science students, normally popping in at lunch-time and, those beyond. The original rationale behind the gallery was that it was to expand the students' activity; they could play in an orchestra or they could act or be involved in the gallery someway. I have not tried to respond to the audience in an obviously literal way but more in terms of showing artists a range of innovative and challenging practice such as Adam Chodzko, and the partnership of two Manchester-based artists, Michael Robertson and John Goodwin. My aim in Bradford is to curate shows, which are quite different. There is deliberately no house style to the type of shows that are produced in the gallery. Working with curators and institutions means that you invariably get different takes on how artists' work is presented. You also get different kinds of publicity and ways in which the work is critiqued which also influences the development of a relationship with an audience within a university. I have also worked with other curators such as Bisi Silva who curated 'Heads of State': the work of Faisal Abdu'Allah, the artist based in London who had been working with photography and printmaking in the past few years. This show toured around the country to three or four venues and developed en route so each show was a slightly different interpretation, as Faisal incorporated different things that came up in the media, such as the death of

Enoch Powell. This work for me was about looking at certain issues concerning survival within the Black community and also looking more broadly at Black survival in Britain.

Audience: There has been no discussion at all about the relationship of audiences to these municipal museums You seem to be quite comfortable talking about how the artist feels and not particularly interested in how the audience feels. I would be much more interested in how those spaces operate, socio-politically. Would you like to chat about that a little bit?

I do not pretend to represent anybody else other than myself. I do not pretend to be a voice for particular communities or particular people, other than myself. I cannot speak for other people. I cannot say what other people's views are on the shows that I have produced. There was a big audience for both exhibitions but I cannot say whether they had an impact on anybody's life. I can only say that they are responses to the environment to which they come out of. 'Imagined Communities' and 'Tampered Surface' both came out of a local authority context. They dealt with ideas of 'community' and 'audience' but not necessarily in an obvious way. I was not interested in dealing with things as mutually exclusive entities. The art world is not a mutually exclusive entity to a real community or to an audience in Oldham. The politics of how an administrator organises these projects within the institution impacts on how they are communicated.

I could have claimed that the show 'Imagined Communities' was all about community. But to a certain extent I have

problems with issues surrounding the social responsibility of art. I am more interested in political issues within the arts that are never discussed such as the actual management of projects in community arts practice. In my experience, much of community arts practice was to do with report writing and having a product at the end. It was not about what people were really thinking. It was about politics, about power within those communities, power within the institution and over those communities.

I'm not a social worker or a social historian although I do have interests in the way in which art is presented to audiences and the way that it is discussed and written about since these things tell us about the particular moment we are in. In terms of 'Tampered Surface', I was acutely aware of the context of Oldham and the immediate vicinity of the gallery to a residential area where a large Pakistani community live. You can get onto very dangerous ground of making a lot of assumptions about what should be seen by whom. I'm not preoccupied with that kind of politic because how can you fix who the audience is? How can you say, "This is our audience." That is the culture we are living in, and obviously it has to be accounted for but I cannot say what impact the gallery or those shows had on a particular community.

People have to engage with these different languages. The gallery has an authoritative voice. In the past the gallery seemed to be telling one story in a particular way. In our post-modern times, it tries to tell a multiplicity of stories, whether it's a fake presentation of cultural diversity or looking at class and history in different ways.

What I have wanted to discuss here today are the relationships, not just of putting on big shows with star names or small shows. Obviously, there are issues about who gets to show in galleries. Part of what I was talking about is showing the way that galleries and institutions work because that shapes processes and what is produced and exhibited. Artists produce things in relation to a particular market, be it the community arts sector or for the commercial arts sector. I have wanted to show the factors which influence how projects are developed.

In the art world when a lot of things are constructed, they are constructed as smokescreens. The way I've been talking today, I do not want to conceal how things are organised and the reasons for doing things. The conception of a show is affected by factors such as the artists that you can afford to get, which artists you can or wish to work with, and who is available at the time and who wishes to work with you. All these things shape shows. Shows extend history, and from that history, stories are told which sometimes don't necessarily admit that those histories have been contingent on all those other decisions like funding. That's why I have wanted to talk about bureaucracy in relation to the arts.

Projects presented at conference
Imagined Communities: Christian Boltanski, Sophie Calle, Denzil Forrester Komar & Melamid, Guiseppe Penone, Tim Rollins + K.O.S, Yinka Shonibare, Gary Simmons, Gillian Wearing. Oldham Art Gallery in collaboration with Hayward Gallery National Touring, 27 January - 24 March 1996

Tampered Surface: Liaqat Ali, Akram Dost Baloch,

63

Iftikhar Dadi, Sumaya Durrani, Durriya Kazi, and
Samina Mansuri and Co-curated by Alnoor Mitha.
Oldham Art Gallery and Huddersfield Art Gallery,
18 November 1995 -7 January 1996.

Art under A Pint: Sue Evans & Tim Robinson,
Simon Goodwin, Mark Wood, Charlie Holmes, and
Jon Angus, Oldham Art Gallery in collaboration
with Oldham Health Authority, November 1993.

Gallery II University of Bradford (Selected
projects), A Bradford Atlas (in association with
Independent Thoughts) Tim Brennan, November
to December 1997;'Night Vision' Adam Chodzko,
5 -29 May 1998 (in collaboration with Viewpoint
Gallery); In a City; Julia Spicer, 25 September- 23
October 1998; Concealed Vision, Veiled Sisters
Sabera Bham, 29 April-2 June 1999; Heads of
State Faisal Abdu' Allah curated by Bisi Silva, 2
March -3 April 1998; Immaculate Perception,
John Goodwin & Michael Robertson 19 February
- 21 March 1997.

[Suzanne Oxenaar]

THE GOLDEN CALF VERSUS MANURE, NETTLES AND DANDELIONS

I am currently an advisor of 'The Praktijkburo',* an office for the realisation of commissions in the visual arts. The office works on a national level in offering advice, guidance and financial aid. It endeavours to stimulate potential commissions for exemplary public artworks as part of a Dutch scheme that offers advice to potential commissioners. The Praktijkburo encourages and supervises projects for local and national government, enterprise foundations and public health institutions, as examples of good practice in supporting the arts.

It is a little like the system of 'angels', yet it is very different. For a long time now, I have travelled all over the Netherlands, into the smallest villages, into the strangest hospitals and prisons. Imagine that I wake up at 7.00 a.m. and travel all the way up to a very small Northern village, as a 'missionary' of art, to find a group of men sitting, all with big cigars. But how can I make them understand art's problem and practice? Usually politicians and art committees want a golden calf to enhance their image and enrich their buildings and facilities, yet simultaneously contributes to breaking down the barriers between themselves, the institution and the world at large. They usually want something that is beautiful and understandable, prestigious and death-proof, preferably made of steel. Deep, but with wheelchair access, possibly with a fountain integrated. They want a big name on it

with integrated company logo, yet championing the vision of the director.

This is a tall order, built on unrealistic expectations and misunderstandings about art, and is the reason I usually have to come and set these people straight. However, I can only do this if I can trust the artist I am working with. It is not only a question of the artist making interesting or good art, it is also about trusting the artist's ability to communicate. What shall I use to communicate with a group of politicians in the north of Holland? I use books because most of the time people have not been in a museum. Most of the time they have not seen art. They hardly have the perspective that we have. They know Van Gogh and often that is it.

'Accuracy of value is defenceless.' These words of the Dutch poet Lucebert apply to art as well. This form of art frequently goes together with violent rejection of this art. My role as curator is to select those artists whom I feel I can trust in their ability to communicate so deeply that I can withstand all pressures and keep making the case for the artist and project. These projects usually take a very long time, months sometimes years. Artists have to stay strong about the project. They cannot get cold feet. They have to communicate all the time with people who know nothing about art, who may be very critical and cynical sometimes.

On the other hand, working with people, who do not necessarily have an art education, has its own rewards. Once they are convinced to accept the proposed content of the project and

*In January 2000, the Praktijkburo of the Mondriaan Foundation became independent, changing its name to SKOR, Foundation for Art and Public Space

commit to it, they take many risks that other conventional art institutions are completely unwilling to take. I have worked with many kinds of projects and many artists. I would like to say something about art in so-called 'total' institutions like prisons, detoxification clinics, and mental institutions.

Let me introduce you to the work of three artists: Michel François, a Belgian artist representing Belgium in the Venice Biennale this summer. Mario Rizzi, an emerging artist from Italy, and Tadashi Kawamata, a Japanese artist known for his projects in public space all over the world. I work with these artists in three different contexts, which are loosely connected to each other. Somehow successful projects catalyse other projects. Art's transformative force does not stop at the gates of an institution. Against all odds, they start making their own gates. On the other side, the unsuccessful stories play a very important role so I will not only describe the successful ones. Projects can also somehow die along the way. A lot of things happen when you are in all those particular places.

The Kiivelanden TBS Clinic is a secure hospital, a kind of specialised prison to observe, control and, if possible, heal criminals who are considered mentally ill and too dangerous to return to society. In this heavily guarded and meticulously strict clinic, Michel François tried to invent a place of exchanges, a place to exercise freedom, like a kind of 'speakers corner' in Hyde Park. This corner took the form of a large, open, transparent cabinet where everyone can put in or take out any form of expression. Intended as a tool, it has become a sort of always accessible storehouse of divers objects, images, and messages: an evolving self-portrait of patients, therapists and guardians. The way that it is used and what may appear there, cannot be predicted. The clinic is a living space and this vitrine is not just an ornament. It is open, active and accessible.

François realised his project in collaboration with all the inhabitants of the institution. He introduced himself by showing them photo-works from his book, 'The World and the Arms'. Together, we visited wards, offices and cells, speaking to as many people as possible. It meant that we spent almost one year just visiting. We knew everybody. We went to everything; Michel even went swimming in the swimming pool. We knew the director and got to know some of the relatives. It was very difficult, especially with the prisoners. They were not waiting for us, and in the beginning, most were certainly not amused. It was the pictures in the book that eventually did the trick, because those people did not know anything about art. So if you want them to participate in a project, somehow you have to make a connection, you have to start communicating.

You have to imagine that these people are completely locked up in very small spaces, in groups of ten. They have their therapies or they are completely drugged with medicines. For them as well as for us, it was a very special event to come in there. We just sat there with Michel François's book 'The World and the Arms' and we looked at the book. It is a book of pictures without text. The same pictures he blows up to big posters that he gives away free. From the pictures they started a simple, very direct

67

conversation. This is how a big project like this starts: with a book, with pictures, talking to each other, trusting each other a little bit. There were a lot of pictures with more sensual connotations. Of course in a place like that, because there are almost no women there, so people start to make comments about it and to make jokes.

The people in the clinic seem to understand this. Simply by showing the work and talking about it, François gained their trust and their co-operation. Of course he was sometimes met with violent or obscene comments but gradually doubts faded and they started forming their own ideas about the vitrine and what it should or could contain. It became apparent that a barely formulated idea could be realised immediately. Realising there was no decisive obstacle had an immense effect on all of us. In this regard a salute must be made to the administrators and the staff of the clinic who were very open-minded.

François did not have the distance of a therapist. He did not want to change anything. He was completely unaware of the nature of the crimes. He tried to exercise his freedoms as much as possible, to evaluate the limits. When, after several months, he was entrusted with the keys and could finally circulate freely in the building, he felt an intense sensation of liberty. By that time, I knew something I had not known when I invited Michel François to do this project; that he had been a prisoner himself once and that his role as a kind of contracted member of staff was an especially difficult one for him.

The relationship with the prisoners, or patients as they are called, cannot be expressed in terms of hierarchy or equality. There had to be a way to exchange something other than violence or therapy. These people have not much else. One man asked where we would situate the vitrine. He had no idea because he was in a room without any general point of view. So, as part of the project, François organised an aerial photograph of the clinic to be taken and the image to be printed as postcards. We were allowed to do that. On the back of the postcard, the text read, 'Where I am, seen from the air'. The postcards were placed in the vitrine for everybody to see and to take.

After a while, the vitrine contained a video player. François offered assistance in making short pictures. One man asked to be filmed walking along the walls of the clinic. Another is seen commenting on his drawings. Another ties a plastercast and a rabbit to his hand and walks around the walls of his room making clicking sounds. Another plays chess against himself. Another makes two shoes dance. Another asked François to film the view from various windows. It is important to say that, for instance, this man is a prisoner who has been inside for four years already and has at least four or five years longer. It puts what they are doing in a context. In the vitrine all the other prisoners could see the movie playing. It needs strength for the prisoners to show this.

Some of the doors of the vitrine are open and some of the doors can be locked because sometimes people put valuable things in there. The prisoners have the keys to the doors because François did not want another locked object. Michel intended the vitrine to be

an everyday tool for the clinic's inhabitants, not just an ornament. He did not intend to predict the way in which it is used and what would appear, seeing it as open, active and accessible. Maybe that concept is hard to accept. Everyone wants to believe that the signed work is finished work.

In order to encourage the idea of the importance of open-ness and accessibility, we wanted to extend the possibility of visits from outside by having artists and others coming in succession to develop a collaboration with the inhabitants. Michel was the first 'curator' of the vitrine and we want the idea of collaboration to continue. It may prove that the vitrine is no longer necessary and other modes of communication can be established. What is at stake here is an idea rather than an object.

By coincidence, Michel François was offered a solo exhibition near the clinic in Witte de With, a Centre of Modern Art in Rotterdam. Right from the start, it became clear that for this exhibition, François would have to refer to his project in the clinic. The work of the prisoners is so impressive that he could have simply brought and placed it in the museum but he felt it was an important step to transform a plan of a cell into a line on the floor of the museum. It is significant that, by making the show entitled 'Manure, Nettles and Dandelions', everything that was inside in the prison came outside and was seen in the art world, in Rotterdam and then in Barcelona. The director of the prison in Barcelona came to that show. I think that it is very important that this kind of project, in a so-called 'public' space, became really public by being seen by

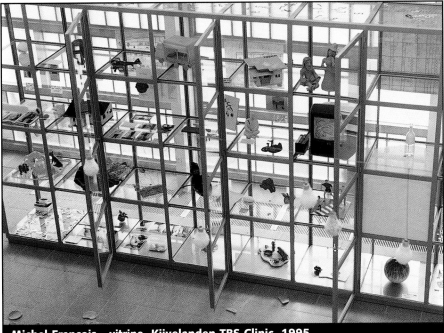

Michel Francois - vitrine, Kiivelanden TBS Clinic, 1995

different kinds of audiences.

'The Fifth Season' is a completely different project, taking place in one of the biggest psychiatric institutes in Holland. When I went to this clinic, I usually talked with a group of no more than six people: amongst them usually a director of psychiatry and one of the nurses, not usually with the patients although I like to do so. The organisational structure of this kind of institution does not work like that. I always like to keep the group as small as possible. It was very important for these people, in talking about art, to make a connection between the community and the clinic since this clinic was very separated from normal life. To make a connection sounds very idealistic and is very difficult.

The clinic was originally built as a series of pavilions. As they are renovating the clinic, many of these old pavilions have had to be demolished. Instead of commissioning a figurative sculpture outside as they wanted, I suggested that they retain and renovate one of these pavilions, since it has a very beautiful architecture, and to invite an artist to stay and work there every season. It was very special that the clinic accepted this proposal and has so far really helped to realise it. As curator for the project, my first proposal invited a Dutch designer, Christoph Seyfert, to give the place an outspoken image, completely different from institutional interiors where every chair, desk and even the cups are the same. At the same time, he had to make the place suitable for artists because it is an extreme situation to stay for three months in the quiet of a ward. His idea was Spartan luxury. The basics are there.

He made a bed, tables, one top chair to sit on, a swing and a bath on wheels.

Each season I invite a different artist on the basis that they will consider it a special possibility and will enjoy being there. The selections tell you a lot about the mentality of the people in this clinic. Artists are free to do a special project or just work there. The programme for the coming seasons includes artists such as Dick Tuinder who will work in five disciplines at the same time. Fransje Kilaers, Roy Villevoy and their daughter Celine will work on a project and a book. De Rooy and De Rijk will work together on a video-project.

Mario Rizzi, the second artist I invited, is a photographer. He says about his projects: 'I did not take photographs nor did I do art therapy. I tried to be a catalyst, a link with the external world, not a nurse, nor a doctor, for the patients who were there at different hours of the day. With no fears, no taboos and no prejudices, photography was the pretext to establish the context. Communicating with images has made us friends, bridging all language gaps.' Rizzi gave throw-away cameras (which were sponsored by a big photo factory) to all the patients who wanted to participate. Of course some of the cameras were sold or used for other things or for pornographic images. Eventually, everybody was making pictures everywhere. Since Mario felt that it was really important to make a book of all the patients' pictures, rather than a catalogue, we found a sponsor for this book.

The patients at this psychiatric clinic were considered difficult cases, similar but not as aggressive as those in the prison. As one of the therapists commented, 'they

have reached a dead-end in their relationships, their careers, and in making sense of their lives. In that personal misery, the social work system fails to provide an effective remedy to all this! Mario Rizzi's project reached out to these people with their considerable traumas and agony, and inner worlds that we know nothing about.

One could argue that the resulting photographs taken by these people are much like those of Diane Arbus. The psychiatrist said that the process itself has taken some of these people out of their isolation. As one of the patients mentioned later in relation to the project, "They tell me I am sick but I function well." This remark acknowledges the limitations that the sickness is proposing and yet it also hints at the role of art which has enabled him to work with these limitations. The art project enabled him to find intimacy with his surroundings and his own experience of them and thus transformed both.

"Work in Progress" located in a detoxification clinic in the suburbs of Alkmaar a city far north of Holland was a completely different project. This time I worked only with the director instead of a whole committee. On a tour of the clinic, the director and I started a conversation about art. He told me he had just been to Documenta in Kassel and commented that the project he really liked was a little village made by a Japanese artist Tadashi Kawamata. So I suggested that we write to Kawamata and invite him to come. The

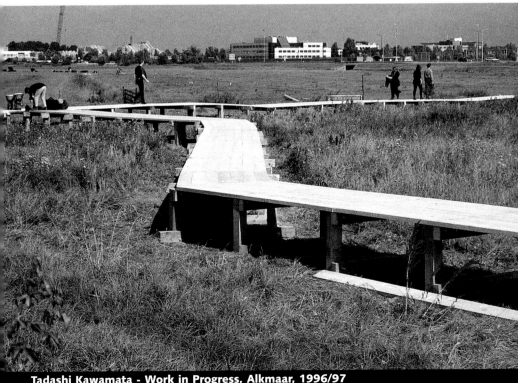

Tadashi Kawamata - Work in Progress, Alkmaar, 1996/97

director had not imagined something like that was possible. Tadashi Kawamata came and he made the first sketch for his project.

Kawamata suggested that a walkway with some stops on the way was built between the clinic and the village. His intention was to build this walkway (of almost five kilometres) together with the patients. It ends at a windmill from where he wanted to build a ship, in order to be able to leave the clinic. As with the other projects, it took a long time to convince everybody but finally the whole project was taken by the clinic and it became part of the therapy of the patients, if they wanted. Participation was voluntary. It became possible to us to get the wood for free from Tadashi's previous project in Vienna. Even the framer gave us a lot of discounts. So we had wood from Vienna to build the walkway here. These things are very important, not only for the artist but also for the patients.

It took two years to build the walkway. Sometimes I came to help and to see how it was going. I was walking with one of the patients, carrying a heavy load of wood. Suddenly she said, "Suzanne, I feel a little bit strange." I was frightened that she would collapse and said she should sit down. She said, "No, I have such a strange feeling. I really feel like the Lord myself. As if I am carrying a cross." Such a project brings out many stories like this one.

The project found its way back into the art world, at an international sculpture show in Munster. The clinic has a boat-building yard, intended to rehabilitate the patients into the discipline of a normal life. After we finished the walkway, we then built an actual boat

there. Just when it was ready, curator Kasper Konig from Germany visited and asked if we, as the Mondrian Foundation, wanted to exhibit in the sculpture show in Munster so I suggested that we take the boat to Munster. We did take it but because we found that there are no navigable waterways all the way to Munster, the boat travelled on a truck, accompanied by all the addicts. I had nightmares that the boat, filled with drugs, would be halted at the German border. In Munster, the boat was moored on a big lake and the patients again built a walkway on one side and the other. Since it is very important to communicate, at Munster we also distributed copies of the clinic's journal, translated into German, which contained regular reports about the art project and information about the experience of addiction.

The addicted patients of the de-tox clinic who came to Munster presented not only the boat but also built another road in the exhibition grounds. The important point here is that Tadashi's project enabled them to enter the world of art themselves. In that sense, the remarks by one of the patients "They tell me I'm sick but I function well," which I quoted earlier, gains a profound resonance. Art has enabled them to become 'homo ludens', playing humans, liberated to work with an otherwise profoundly desperate and joyless reality. I feel that it is always possible to communicate things through art. Art is its own unique reality too. Paradoxically art has a separate reality yet it crosses conventional boundaries between patients and therapists, psychosis and normality. This art in the context of so-called 'total institutions' is

not so much therapeutic or beautiful but, instead, can transform the whole situation. So while asked to deliver the golden calf, people usually end up with manure, nettles and dandelions.

Audience: Many of the programs talked about giving people meaningful work to do. This is work for art or work engendered by a leading personality, with the charisma and the extreme delicacy of becoming one of that community, whilst not being it. Somebody might have said, "It's good that these people should work and stop being neurotic. They get outside into the fresh air and build a path from here to the city. That would be a good thing." What is different from a path built to the city in the name of art and a path that you might build just to keep you occupied?

It is a difficult question. Maybe I react too quickly but I think that somebody like Tadashi Kawamata is working on his own ideas. He does not come to put the patients to work. He comes because he has an idea. He has to make his idea. What I do know was when I was in New Mexico last summer, I discovered that if you call the tourist information, you get a prisoner on the other end who gives you information. In New Mexico, prisons are private now and have to make their own money. Prisoners are very cheap workers. I think that this is physical 'work'. I cannot see making a photograph or a film as putting people to work.

Audience: You invite an artist who has an idea and uses cheap labour. If the work ends up in Munster, it legitimates the artist and not those people who were involved.

I totally, totally disagree.

Audience: I think that if I was a patient I would probably ask if the kind of qualities that the artists express and the quality of what happens extend any respect to me?

I do not agree at all. To begin with, these patients, especially these addicted patients are normal adults, just like you and me. They can choose to participate in the project. They get very good information about the project, if they want. Nobody obliges them to participate and they become part of a beautiful work and they are honoured for it. You could say that it is in more honour of Kawamata, maybe, but if it was not with them, he would do it anyway.

Audience: How can anyone in this room speak for the patients? I find that absolutely extraordinary.

Maybe I can tell you that at the same time, when we were doing this project with the detoxification clinic, a theatre school, 'Das Art' from Amsterdam, visited the project and they wanted to continue the way at their school. So the students from there came to work here with the patients and the patients went there to work with them. You can see it as working, but this is not building the Burma line. This is creating, realising an idea.

Audience: Would these patients have had the opportunity to do this, if they were in the confines and traditions of institutional convention.

The answer is probably no. It requires the artist as creative thinker to bring these new ways of working to the institutions.

Exactly.

Audience: I think that there is a real danger of institutions not empowering the people who happen to be in there. There is

73

*a real danger of not really changing the
actual power situation.*

You have to risk tangling with those
bits of the structure and society.

*Audience Question: Does doing a little
bit make it bearable not to change the
institution in other ways?*

Maybe this is an answer. I understand
how difficult it can be. How far can you
go in? How far do you collaborate when
you go in? How far do you become part
of the system? On the other hand, in the
inside of the heaviest prison in the
Netherlands, there is nothing, nothing,
nothing visual. So you can also say, "OK
we don't do it."

When I was 18 years old, I felt so
sorry for women that were in a particular
prison that, with a group of people I
started making theatre pieces outside
every Sunday, so the women had
something to look at. One day, we were
attacked by a group of Hell's Angels and
the people in the prison saw it and asked
us to come in. I was very divided since I
had two problems. The first was whether
to report the attack to the police and
perhaps put the Hell's Angels in gaol. The
second was whether to enter the
institution and the system of the prison,
that I was fighting on the outside. I
thought a lot about it, and then I
thought: I know who I am and I know
what I want to do. I would like to go in a
prison and make theatre with these
people, make movies with these people,
but I have some rules, for instance: I will
never give any of my information to a
therapist or whatever, about the patient,
about the prisoners. I also never want any
guard during my teaching. So perhaps I
am at some risk but I do not want
anybody there.

[James Marriott and
Jane Trowell - members
of PLATFORM]

"WORDS WHICH CAN HEAR"

EDUCATING FOR SOCIAL AND ECOLOGICAL ART PRACTICE

JAMES MARRIOTT

Platform brings together individuals from a variety of different areas in the arts and the social sciences to work on ecological and democratic questions, pooling creative abilities and creating projects together. Since 1983, Platform has created a range of collaborative art works with the combined skills of sculptors, community activists, engineers, musicians, psychologists, writers, economists and many others.

Based in London, almost all our work draws from, is fed by and tries to feed back into the place that is our home: the tidal Thames Valley and London, the metropolis that sits within it. The majority of our work takes place in public. Physical sites for our work may vary; we can be out in the open on a street, or a bit of wasteland or we might be in an enclosed space. I feel pretty uneasy with the term 'public'. It does not seem to clarify anything. Although we do not see what we do as 'community art', we certainly perceive what we are doing as interacting with two distinct communities: communities of place, such as people on a bridge or in central Wandsworth, or communities of interest, such as the Congregational Church of Hungarians in Hammersmith or a gathering of anti-oil activists. Both communities are 'public'.

We create events (performances) and try to make them as open as possible. We have never charged for anything that we have done. It is extremely rare for us to create an object. Our work tends to evolve very slowly to a response to a particular

concern, a particular group of people and a particular place. It is the subject, or you might say the 'political intent', and the locality which determine the form of work. The subject is the overlap of people, place and desire which, in turn, dictates the kind of form for the work and creates it over time. It may vary from a street performance to a piece of engineering. For all these reasons we hardly ever work to commission, since that system does not seem to work for us at all.

Here are some examples of projects which illustrate these points. In 1992, we created a project called 'Still Waters' based upon the idea that we live in a city set in the valley of the tidal Thames, dominated by water that flows down from the hills in the north and the hills in the south. Underneath London lies fourteen rivers, fifty-six named brooks, streams and so on, buried for at least a century.

Our aim was to provoke people, to engender a climate of understanding where the resurrection of the rivers became inevitable, in other words: to encourage people to say "let's dig the damn things up". We worked on four particular rivers, combining the skills of performance artists, a psychotherapist from the local hospital, a writer and a teacher, who worked together on the River Fleet. Publicists worked together with another performance artist to create a project called the Effra Development Agency which was successful in provoking the local press into saying "Let's dig up the local river".

The fourth river was the River Wandle, which is not completely buried, and enters the Thames at Wandsworth. Platform worked to create a project about the physical and the spiritual power in the

history of the River Wandle. On this project, we brought together a sculptor and an economist, who endeavoured to encourage people to think about the river through performances, public meetings, guided walks and exhibitions. To think about the fact that this river in southwest London had been a sacred place in the Bronze Age, a site of religious worship and, later from the tenth century to the 1890s, had been a great milling river, but was now redundant as a source of energy.

This project of 1992 led onto 'Delta' another project in 1993, in which a sculptor, a musician, and a hydro-engineer collaborated to install a micro-hydroturbine in an old sluice gate to generate electricity for a nearby school. They painted the sluice gate gold, and mounted it within a stone entablature carved with the names of animals that had been in the river and installed a church bell which rings at the highest and lowest point of the tides. Some of the electricity from the micro-hydroturbine powers that bell whilst the rest provides electricity for the school. We also worked with the school on a performance so that they could build emotional links to the river in parallel to building an understanding of its physical nature. Work of this nature unveils very slowly over time: the rivers project is over ten years old and still continues.

We are currently working on a project in the City of London, a development from a project called 'Homeland' where we tried to encourage people to reflect upon the nature of their home in relation to commodities that they use. Raising awareness, for example, that copper comes from a copper mine or that electricity originates from a coal mine in

Wales is a way of understanding the relationship between daily life and the intricacies of international trade.

'Homeland' was a project that in some ways did not work for us. So we re-framed the idea as an examination of the relationship between transnational companies which are based in London trading in oil, the commodity of oil itself and climate change. The project was called '90% Crude'. We began to create works to provoke people to think about it. We created two newspapers (Ignite) which looked exactly like commuter newspapers given out in tube stations but the content was completely different, giving information which was critical of issues such as transnationalism. With a local college, we also created the Agit-Pod, a solar-powered, zero emissions vehicle which can project slides. We created workshops bringing together people, such as oil activists and corporate traders, with different perspectives on the issue of oil. The focus for this project is now on place: the financial quarter of London, in the City.

Within each of these examples are five main elements which contain the way we work: practice, place, time, art, and success. Firstly, all the work we do is 'art', in the broadest sense of Beuys's 'social sculpture'. It is based on the belief that individuals, regardless of discipline or whether they have trained as an artist, can involve themselves with art as a kind of magical substance. The attempt to change society to make it more democratic and ecological is in itself a kind of art practice.

Secondly, this philosophy and way of working raises the question of 'success', in terms of the art work. How do we determine the success of what we do, as a

'work of art'? The central tenet of our work is obviously the creation of a more democratic and ecological society and so the artwork is about social and ecological evolution. The aim is very clear but to measure such an evolution is extremely difficult, not least because notions of democracy and ecology are constantly changing. So how do you assess if your work is making the world more democratic? For me, this remains an intuitive process. Ultimately you can only assess whether you have been successful or not on an intuitive basis, as you would assess the success of a poem or a painting. I know a poem is good because of the way it works on me.

'Time' in a project lasts also affects an assessment of its success. The project in Wandsworth and Merton started ten years ago and still continues. We never imagined that it would, when we started. The work rolls on out of that tiny little project. It has never really had an end, which creates problems in assessing how successful it is, since it is always turning another corner. The other thing to say about 'time' is that we tend to take a very long time. We started working in the City of London three years ago. I certainly think that we could be doing it for another decade.

The next thing is 'place', an extremely important element in our practice. Our work derives from an ever deepening sense of place, which I would describe in two frames: ecological and social. Ecological place, for example, is the nature of London as a tidal valley set in a temperate zone, with deciduous woodland and waterways both saline and fresh. An example of social place is the nature of London as a location inhabited by 8 million people, many of whom have gathered together with the intention of trading.

Finally, the major element is our methodology of practice. It is vital that what we do is not only about democratic and ecological issues but that our methodology is democratic and ecological. What is ecological practice? It certainly influences how you approach very obvious things, such as selecting the materials you use. Are they recycled or not? What is the life cycle of the paint that you use? If we work abroad, how are we going to travel? What is the carbon output of our activities?

Furthermore, it is important that our beliefs in democracy direct the way we operate as an organisation. We discuss everything, in small or large groups. Each person must have time to discuss. We also need to place ourselves within the social fabric. So we spend a lot of time networking with lots of local groups, building up an understanding by going to meetings or talking on the phone with the local Friends of the Earth group, a civic society from Wandsworth or an artists' group in Newcastle.

JANE TROWELL

We would like to invite you to join in imagining a Fantasy Art School. What we are going to do is to raise some of the implications of socially-engaged practice on the curriculum of art schools now and in the future. I am going to go through a few of the skills and attitudes that we perceive to be vital ingredients of working across the domains of social and ecological change and social justice.

As you may know, there are many environmental art groups as well as many environmental campaigning groups. There are also many human rights groups, social

groups and artists' socially orientated projects. However, what is difficult and stimulating to say is that environmental issues, ecological issues and social issues are actually indivisible. Take, for example, the issues surrounding asthma. It is related to road use, transport issues and to issues of poverty. Some of the highest incidences of asthma in London are in the borough of Tower Hamlets, close to the Tower of London. Yet residents here own the least number of cars per capita. They run a greater risk of asthma due to other people's use of cars.

It is not easy, but Platform is also trying to remind those we work with in the ecological domain not to forget that people have complicated material desires,

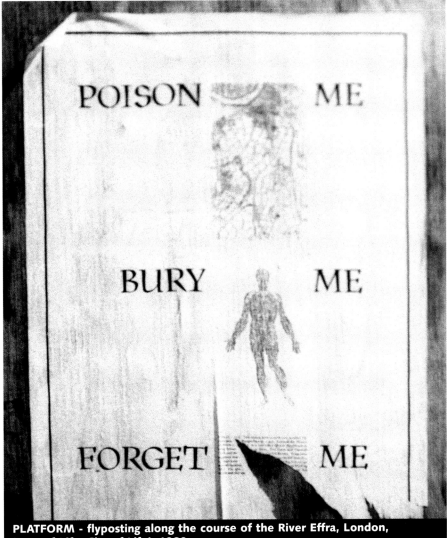

PLATFORM - flyposting along the course of the River Effra, London, 'Tree of Life, City of Life', 1989

which need to be taken seriously and addressed with care. How does an art school deal with issues of consumption, material reality, energy? Conversely, is art exempt from ecological considerations? Why shouldn't we evaluate the art world and art schools in terms of environmental impact? How does the art school curriculum deal with students coming through the door, who want to understand and feel passionately about their impact and the impact of their society on the earth? How do you encourage in art school a fascination with 'place' if, as someone said earlier, art schools are 'training grounds for the white cube'? We would lobby strongly for teaching the concept of 'place', rather than 'site', since defining 'place' in terms of ecology enables us to be more imaginative. 'Place' embodies the length of time a place has existed, all that has happened within it and all that will happen within it. 'Place' is about history, about belonging or not belonging, and about ecology.

To work in this field, we are not suggesting a lessening of aesthetic expertise. We are not suggesting a loss of personality or values or a loss of craft skills in a particular media. Specialist skills, aesthetic sensibilities and experience are invaluable. I include the term 'experience' because experience needs to be valued wherever it is found, in informal or formal settings.

What specialist skills are required to work in this way? We believe that artists who wish to work in this domain (to struggle with it as we do) have primarily to be actively committed to democratic practices, not just passively complaining or protesting about hierarchies but also by examining your social process as a lecturer

or as student, within a studio or within the public domain. Artists need to learn these skills because, in the public domain, artists meet all kinds of people who will challenge you about the democracy in your practice. So there has to be a space in art school where the term 'democracy' and democratic issues are debated between students and staff.

In this regard, one of the most crucial lessons that we continue to learn is to ask the question: Who is not here? Who is not in the room? It is a very important issue to examine who did not take up the invitation or who is not included, be it in terms of gender, race, class, whatever. These may sound like clichés but they are not. Then to ask another question, 'Why are they not here?' That question connects with being committed to revealing power constructs. We must not hide who has got the power. We must acknowledge who has got the power, we must acknowledge it. We need to acknowledge who we are, who our students are and therefore who is not teaching, and who is not being taught. We need to look at power constructs and we need to develop a sense of what social justice might mean. A willingness to include means thinking cross-culturally: this way is not the only way, the only reality. We are wrong to think that the only reality is in a European-influenced art context. If you cannot talk to people outside your culture, outside your class, then how can you possibly work in the public realm? Within the lesson of inclusion is the question, 'In whose interest is this work being done?' Be honest about it because people smell a rat really quickly. When you know and can articulate in whose interest the work is being done, then you can speak to those people openly,

without compromise or fudge.

You have got to be able to give constructive criticism and take all kinds. If you are working in public, anyone might come up and say, "What the hell do you think you are doing?" or "I don't agree." If you walk away from the conflict, if you won't engage with them, your public art work, regardless of its form, will not succeed because whoever has got a problem with your work is going to damage it in some way or other. Conflict resolution, the readiness to engage can be taught. It is a skill which takes courage, which is often hard. It is about having the courage to deal with difference in public and the knowledge that some people will think what you are doing is absolutely abominable. You have got to know why you are doing something and to take responsibility.

Humility is a big issue for Platform. You have got to be honest about mistakes and learn from them. You have got to be public about failure but you are not out to humiliate yourselves. You are out to share. I judge the most failed work to be when the inter-personal relationships between participants or passers-by and the core project have been a mess. If we have not managed to resolve conflicts, we have not managed to honour and respect each other. Sometimes, this happens despite everything, but the aim is very important for collaborative practice. I think that in our work, if the social process has failed, then we have failed. The quality of social relationships is a big indicator of success because that is what is going to last, in the end.

Democracy is often equated with giving or having a voice. But if everybody is talking, who is listening? Someone once said, 'We were given one mouth and two ears, so we should listen twice as much as we speak.' The act of listening is a radical activity and it is hard to do, hard to let go sometimes and shut up. However, if you have patience you can develop these skills. We propose that teaching artists to listen and hear should be part of an educational process for artists who wish to work with issues of ecology and social justice in the public realm.

Platform operates a consensus-based model rather than taking a vote. We all have to come to an agreement. It might take forever and sometimes we do have to agree the limits. This means that when you come through that process of struggle, of listening repeatedly, you have a strength. Knowing that everybody has compromised somewhat gives a feeling of solidity. In art schools, consensus decision-making is a skill that perhaps needs thinking through in the delivery of critical sessions and group seminars and the degree to which students are listened to or have an equal voice with teachers. Democracy takes time - you can't clean a river once.

Individual and collective ways of working are a big issue in art schools where individual creativity is highly prized. Group or team-based projects do not necessarily diminish the individual; we suggest that the students are strengthened, but only if you fully acknowledge individual positions. You need to listen very carefully in such work because, through the process of listening, you will find all kinds of weird and wonderful sides to each other that you never knew. You need to be able to make allowances for people and allow people to be very surprising. Also not every process

has to use words to be understood. There are other ways of debating and developing collaborative projects with people whose language is not the same as yours, with people who are not skilled at or at ease with debating in public or even in a small group. Many visual techniques exist to develop collaborative projects that are visual which can be very releasing and inclusive. Collective working is fun and exciting. The best parties we have had have been through working together with lots of other people. The pleasure of being the unique artist, of course, is very seductive but the pleasure of a damn good party after a collaborative project is phenomenal. bell hooks has called it 'the learning community' where everybody is learning, everybody suffers and everybody has the pleasure of achieving.

The mission statement underpinning the curriculum for this fantasy art school rests on this question. 'How are my actions contributing to ecological and democratic progress? How are they interacting? We have heard of one educational model which is moving towards such a curriculum: the Visual and Public Art Course recently started by Suzanne Lacy, Judith Baca and Luiz Valdez at California State University at Monterey. Over four years, the course is inter-disciplinary, cross-cultural and technological, using a pedagogical model of 'service-learning'. Artists working in a social, public domain are considered to be in a position of service. Artists need to learn to serve communities. Students study historical and contemporary analyses surrounding the concept of 'community' and 'audience' Four core skills are taught: collaborative and community planning, production, critical and evaluative skills, and

communication skills in terms of learning to listen to a community other than your own. It will be interesting to see how this school evolves. I really hope that the founding faculty make public the journey of that art school because that is the only way we are going to learn.

Theirs is an overt agenda which can be critically and politically analysed. Students and staff sign up for this. I think schools like Monterey give us a really good opportunity to re-evaluate and challenge our own educational assumptions with regard to social and ecological practice, and move the fantasy to reality.

Projects presented at conference

1992 'Still Waters' which proposed the recovery of the buried rivers of London;
Ongoing since1993, 'Delta' which involved sculpture, music, performance and the installation of a micro-hydro turbine in London's river Wandle;
Since1995, founder Trustees of RENUE, the largest urban community renewable energy scheme in the UK, which has been awarded a £1 million grant from the Millennium Commission;
1993 'Homeland', a commission from London International Festival of Theatre, investigating Londoners' links to producers through international trade systems;
Ongoing since 1996, '90% CRUDE': a multi-faceted project focussing on the culture and impact of transnational corporations, global finance, and their dependency on oil, with particular reference to London and Londoners.

Bibliographic reference

bell hooks, (1995) 'Teaching to Transgress, Education as the Practice of Freedom' published by Routledge

STRATEGIES

Patricia C. Phillips

Hugh Adams

Jane Calow

[Patricia C. Phillips]

PUBLIC ART: PROCESS, PRODUCT AND RECEPTION

This presentation is excerpted from a longer essay "Points of Departure: Public Art's Intentions, Indignities and Interventions" first published in 'Sculpture' (March 1998)

The psychological and political dimensions of public and private have been set adrift by rapid changes of social and technological environments and insatiable appetites stimulated by market-driven, commodity-crazed economies. The intersect of public and private constantly shifts and often exists simultaneously. Perhaps the most germane distinction between private art and public art is economic. Most independent work is produced for the market, finding its way through purchases and acquisitions into personal and private collections. Although not entirely exempt from these mercantile pressures, public art responds to other capitalistic forces of supply and demand; approval develops in other ways. But it is only occasionally a brave alternative. Rosalyn Deutsche and other critics have disclosed that public art can be alarmingly compliant.

In the past decade, the geography and economy of public art may be the most significant sites of change. When I first began to write about public art more than a dozen years ago, the dominant model was a large sculpture-permanent or temporary - located in a civic or quasi-public space. The site could be an open space in the urban fabric generally understood as part of public territory. An often perturbing alternative to this was the proliferation of outside or inside areas that were provided, hosted and, more importantly, regulated by a corporation or private developer. These quasi-public spaces were available during particular hours and to a selected clientele. There were published and unstated rules. Typically, projects in these public spaces were funded by state and federal programs or private and corporate support.

Public sites as formal settings for public art remain a conspicuous manifestation. I suspect that if Komar and Melamid were to conduct a 'People's Choice for Public Art', the statue or fountain in the middle of the plaza would win hands down above any other consideration of site, subject, or material evidence. And yet theory and discourse on public art are routinely dismissive, if not disdainful, of these familiar manifestations of public art. A review of recent projects, publications, and conferences indicates that public art has an inquiring, critical potential that some of its most notable achievements leave unexamined.

There is still an interest and a funding structure for projects in public spaces, but there are clear signs of a growing preoccupation with the content and structure of communities and institutions that generally serve and periodically define different publics: the workplace, neighbourhoods, schools, museums, transportation facilities, and other major urban systems. An increasing number of artists manoeuvre in the intricate web of networks that chronically shape and reproduce ideas of the public. Support for this work is another complex skein. Projects are often sponsored by independent art organisations and selected state or federal programs, and a combination of private and public funds. Some of the work is artist-initiated taking more autonomous and idiosyncratic paths toward realisation.

In the January 1998 issue of Harper's magazine, critic Dave Hickey contributed

the essay "Why Art Should be Bad"[1]. As Hickey depicted and diagnosed with lucid amusement the current plight of art, artists, and the marketplace, I wondered how some of his provocative observations might apply to the subject of public art (not something that Hickey takes on, but how fascinating and shocking this would be!). He proposes a suspension of holier-than-thou attitudes and an acceptance of art's frivolous, even unsavoury, characteristics. Without addressing this particular proposition, I am intrigued by his appeal that artists "be more concerned with good effects than dramatizing their good intentions."

It is paradoxical that despite conspicuous controversies in the past fifteen years, many people would argue that public art is generally a bounty of good intentions. Obvious exceptions aside, there is a common assumption that public art seeks to maintain an equation with common good. The 'good' often arrives in the form of an amenity or a diversion, but artists' intentions, if not high-minded, are generally perceived as sincere. But what artistic event or evidence is good for a community? What will people admire and identify with? How does art satisfy? How do people benefit from public art? These and other questions indicate that 'good effects' are more irksome.

With few magazines and other publications even marginally interested in the public agenda, there are only sporadic surges of thoughtful public art criticism. But some recent publications, conferences, and projects focus on current issues to stimulate conversation beyond explicit 'dramatized good intentions' to more evasive 'good effects'. The lines have been drawn for some time between traditional-static-formal and speculative-dynamic-contextual dimensions of contemporary public art practices. The highly visible and publicised project 'Culture in Action' in 1993 announced that, in spite of the predominant model of sculptures, murals, and amenities in cities and communities, public art has never been a single-minded, object-driven enterprise. Organised by curator and writer Mary Jane Jacob for Sculpture Chicago, 'Culture in Action' dispersed a group of artists to diverse neighbourhoods in Chicago to pursue community-based art projects[2]. In most cases, participating artists identified groups and constituencies that functioned as a new hybrid of collaborator, client, or context. Ideally, if not actually, communities led artists to pressing subjects and issues. Factory workers, residents of public housing, neighbourhood teenagers, or the past and present community of women in the city were anchors and incentives for a broad range of artistic activities. Jacob was the first national curator to organise and promote such a high-profile, community-based public art initiative. 'Culture in Action' was presaged by her earlier exhibition 'Places with a Past' in Charleston, South Carolina as well as a number of activist precedents including the Chicago Mural Movement[3]. A consequence of this and other projects is that the respective roles of artists, administrators, curators and critics became more discursive and negotiable, and 'good effects' - the aesthetic productions of prolonged process - became sundry and shifty.

Hard on the heels of the Chicago project, a series of essays collected and edited by artist Suzanne Lacy (also a participant in 'Culture in Action'), 'Mapping the Terrain: New Genre Public Art' remains a critical text at a significant juncture in

public art practice[4]. Clearly, there were other historical forces (Duchamp, Dada, Fluxus, Beuys, etc) infusing a more progressive, process-oriented and collective approach to public art. The essays cited ongoing and new projects and diversified publics, while framing some of the important, often intractable, issues of situation a public and an artist in public art.

It is difficult to condemn the 'good intentions' of these and other projects, but motive and outcome have been examined and challenged. Critic Miwon Kwon, among others, has questioned this community-based work for its opportunistic involvement of individuals in order to produce work with little lasting significance for the community that it employs (or exploits). In the 1996 Fall issue of 'Documents', (in a passage also cited by Tom Finkelpearl in 'Uncommon Sense',) she writes:

"...salutary efforts are being made to 'democratise' art - to engage and enlighten a broader audience, to give voice to marginalised groups thus far excluded or silenced in dominant cultural discourses... But in recent years, such efforts have also become formulaic: artist + community + social issues = new (public/critical) art.... In turn, these 'communities' identified as 'targets' for collaboration in which its members will perform as subjects and co-producers for their own appropriation, are often conceived to be ready-made and fixed entities rather than fluid and multiple. The result is an artificial categorisation of peoples and their reasons for coming together. My characterisation of current community-based art programs is intentionally reductive here in order to break through the halo-like armature of social do-goodism that protects them from incisive analysis or criticism." [5]

Certainly, good intentions cannot blind us to critical insights. Nor should they allow us to be routinely dismissive; good intentions often produce good effects. Five years ago I also raised issues about a new travelling troupe of artists that was circling the globe to produce work for particular projects or expositions. Whether involved in international distribution or regional remediation, the predictable roster of artists began to constitute a packaged exhibition. Even with the requisite preliminary visits, there was the succinct sense of artists and their works being parachuted into fashioned, artificial opportunities. It was a gunslinger approach to public art. The works were often gratuitously site-specific; community was an abstraction and occasionally a convenient justification.

Given these reservations, it is important to differentiate modalities and to identify pertinent issues. How do we critics and artists establish and clarify positions without being reductive, shallow, sentimental or noncommittal? How do we map the critical points in between displaced and aloof and specific but opportunistic public art?

'Culture in Action' remains a precedent for similar initiatives, such as the Three Rivers Arts Festival's 1996 'Points of Entry' cited by Kwon. The artists in 'Points of Entry' formed different concepts and methodologies to work with community groups. Artist Ann Carlson worked within the health care system shadowing employees in neo-natal and obstetrical units. Group Material appropriated the Festival program guide adding passages about Pittsburgh's hidden histories elicited during a radio call-in program. The accumulated voices challenged the 'professionalisation of community-based

art' and complicated any secure concept of community 'by introducing unexpected observations, critiques and agendas'.[6] A part of Daniel Martinez's ambitious project began with correspondence with inmates on Pennsylvania's death row. Fifteen 'conversations' by letter emerged. Martinez asked these inmates to draw self-portraits. Their drawings were enlarged on nylon banners, like those used throughout the festival. They were placed in a long corridor between two prominent sites (the stage and food-court) at the park. By presenting this collection of poignant self-portraits by death row inmates rendered invisible by society as they wait to die, Martinez's project presented the terrible irony of capital punishment as a socially-condoned response to violent crime.

Clearly, community-informed work is not univalent. It is important to acknowledge and examine independent strategies and to consider subsequent projects for their particular focus. Is a project simply a knock-off or is there an enhancement - a fresh exploration of relevant ideas? What are acceptable ways for an artist to learn about and work with a community in an ethically and aesthetically responsible way? In spite of its many perils and limitations, how do we ensure that an engagement of community remains a permissible subject - even a central mission - for public art?

But as artists enter public institutions, they must thoughtfully study and experience particular cultures and their histories in order to clarify what they hope to accomplish in an institutional environment. For example, with many programs and incentives in place, more artists now have opportunities to work in public schools (ie. *State funded schools -*

Eds). They sometimes produce work with and, presumably, for students. Unlike work in a public site in the city, the student citizen may not have the same choices to engage or avoid work. Public art projects often are adopted by a course or curriculum; students may be enthusiastic participants or disenfranchised captives of a belaboured process. Schools are not always constructive environments; they are never neutral sites. Public artists working in school environments are not art teachers; they are temporary visitors and potential insurgents. It is important to understand the circumstances - the opportunities and responsibilities - of this kind of work. Do good intentions mean to accept or context institutional conditions? And how these cultures and contexts influence and perceive good effects?

Systems have histories that embody dynamic characteristics. Institutions engage and employ people, and it is essential to acknowledge the conditions of scrutiny and service that an artist may unwittingly support. In truth, as much as I have advocated for artists to embrace 'public' as an errant idea rather than a fixed site, the research, analysis, and insight required for artists to work critically and constructively in schools, with transportation and maintenance systems, or in art environments is a daunting, often discouraging task. All institutions are weaves of opportunity, expectation, compromise, and prospective failure. They are concurrently - and paradoxically - tenacious and fragile. All the more reason for artists to seek opportunities and define new roles in these public worlds.

If lucky, most artists work on a series of independent projects. A park here, a school there, and an exhibition next year. Probably

the most thorough way that an artist can understand the institution as site and subject matter is through prolonged, sustained involvement. The many years Mierle Laderman Ukeles spent as artist-in-residence with the City of New York Department of Sanitation is a prime example.[7]. After almost two decades, she understands the systematic intricacies and the multiple roles required of an artist to remain intellectually and artistically agile enough to deal with the changes and constraints of a vast municipal organisation. But this is neither structurally nor economically feasible for most artists. So how do we accept the existing limitations and still encourage the most challenging, responsible work to flourish? How do artists enter new communities equipped with incisive questions, clear objectives, and an openness to outcome?

How can public art be provocative in a political and economic atmosphere where controversy is seen as an impediment to funding and another nail in the coffin of critical public art? Thinking again of Dave Hickey's passionately honed and possibly heretical observations, should public art be anything but bad? Can it afford to be anything but good? This is the internal, irreconcilable dilemma - and opportunity - of public art. To be public in the fullest sense of the work, it must be difficult, disturbing - and sometimes bad. To be supported, funded, and preserved, it must be agreeable, inspiring - and good. How can public art abstain from a critical position in public institutions? But how does critical work find its way into institutional sites? If public art simply treats complex sites as neutral settings, why do we need it? And if it is simply appropriate and acquiescent, why should we want it? As members of the

public, artists can challenge and propose a shared vision that opens new perspectives and angles on these vexing issues.

Some will argue that public art should be easy to get. I suggest that public art is sometimes hard to accept - that it can insistently raise questions and issues that challenge our complacency and confusion about our place in the public world. Of course, this may be a recipe for disaster, but the other alternative is a franchise of user-friendly art. In spite of some artists' and critics' attempts to legislate (to make certain subjects or strategies off limits), public art is inherently political and constitutionally problematic. Community-informed public art remains the most promising model for deployment and involvement. It is where artists have the most promising and demanding opportunities to embrace the irreconcilable, insurgent aspects of public art and to generate creative, constructive momentum with other members of the public.

In summer 1997, the exhibition 'Uncommon Sense' occupied the art museum as a site for public projects and interventions. Organised for a specific museum and urban environment within a limited time frame, the exhibition is documented in a publication that offers an historical, contextual, and philosophical background for this initiative[8]. Received with confusion, if not contempt, in some quarters, the exhibition and publication are another strategic case study, (like 'Culture in Action' and 'Points of Entry' in contemporary public art. Curated by Tom Finkelpearl and Julie Lazar, the exhibition sought "to create a public dialogue within a space that is historically hostile to this sort of endeavour." Finkelpearl cites projects that take art audiences away from galleries and

museums into cities and communities (such as 'Places with a Past'), but he also advocates for "fostering interaction" in the museum. Lazar references Joseph Beuys' ideas on art and teaching [9]. She asks: "How can a museum, which produces (one-way) transmissions of curatorial theses, become engaged in sympathetic dialogues or debates with artists and audiences?" But she also cautions that the "projects may not look like art at all." It is important to remember that 'Culture in Action' stayed in the streets. 'Uncommon Sense' was a bold speculation that the time was right for this kind of initiative in the art institution. Perhaps its mixed reception indicates that the time was ripe.

Most of the artists working in neighbourhoods and municipal systems with special populations, including fire stations, community centres, classrooms, and rodeos in order to produce work for exhibition. The museum served as a facilitating, connective site. Did the exhibition bravely and cogently challenge the conventions of this institutional culture, or was it a disappointing occasion of the domestication of public art? Was it an inroad or a retreat? Did public art enrich or subvert the predictable programs of art appreciation, or did it lose its edge leaving the Museum of Contemporary Art unaffected and the art itself impoverished? Good intentions, good effects.

In her essay in 'Uncommon Sense', Marita Sturken reminds us that the success of each of these projects was contingent on process. And as she suggests, the merits of the entire exhibition must also be based on a curatorial process which had negotiation as its subject and methodology. "These works have pushed the traditional art negotiation with materials and conceptual ideas, to engage with the negotiation of workers, television producers, businesses, and the city itself."[10] Process and negotiation are invaluable, but they are never isolated from intent or content. They are not unquestionably or uncritically good.

It is important to distinguish how work emerges from artists working with communities, from work that develops from artists' theoretical/aesthetic positions that connects with a relevant constituency. Given these contrasting strategies, it is simply too easy to see community-informed work as either wholly constructive or coercive. Not surprisingly, there are many examples of 'good intentions' and a paucity of 'good effects' that conform to a historical understanding of what art is, where we encounter it, and what is the acceptable - or expected - range of physical evidence.

Public art has reached a point where the extent of variables has produced a shocking critical crisis. Not only are the actual forms and duration of public art unpredictable and errant, but the contexts are far-ranging and difficult to understand thoroughly without prolonged research and experience. Most approaches to art criticism are ill-equipped and disinclined to address much of this work. It is this predicament that creates a reluctance to tackle unruly issues and new subjects (a vacuum), or produces a critical 'rush to judgement' of egregious oversight (an indignity).

Community-informed, institutionally-based public art generally does not seek or find closure. Projects are frequently dispersed, decentralised, and discursive. Much of it is unmistakably unwieldy, but rather than dismiss challenging, even courageous art, it is important to ask questions about process and result. What

91

kind of administrative support and critical environment are required to support and challenge new work? Can an illumination of process embedded in content enable us to make meaningful connections between good intentions and good effects?

Public art continues to summon new concepts of the artist and new ways of working. But public art fails when it misunderstands its intrinsic connection to all art. And criticism misleads when it neglects to recognise its history or its speculative role in new contexts. Opinions must be points of departure rather than final destinations. Public artists must begin with clear objectives accepting that outcomes must remain open, unforced. Critics must avoid being smitten with good intentions or 'blinded' by good effects. Perhaps for all of us who share a critical commitment to public art, the best effect is better process.

92

Endnotes

1) Dave Hickey 'Why Art Should Be Bad' in Harper's magazine, January 1988 p.16

2) Mary Jane Jacob 'Outside the Loop' p.50 and 'Eight Projects' p.62 in Eds. M. Brenson, M. J. Jacob, E. Olson, Culture in Action: a public art program of sculpture, Bay Press, Seattle 1995.

3) Slide documentation available from Art on File International, Public Art Development Trust, London

4) Suzanne Lacy, editor, Mapping the Terrain, published Bay Press, Seattle 1995.

5) Miwon Kwon, "The Three Rivers Art Festival" in Documents 7 (Fall 1996) p.31 - 32

6) Group Material, "Introduction to the 1996 Festival Program Guide" in Points of Entry: Three Rivers Arts Festival. Three Rivers arts festival, Pittsburgh, PA. 1997. p.23

7) Editors' note: Laderman's residencies are outlined in p.281 'Mapping the Terrain New Genre Public Art' Ed. Suzanne Lacy, Bay Press 1995

8) Tom Finkelpearl, "Abstraction and Attraction" in

Uncommon Sense, The Museum of Contemporary Art, Los Angeles, 1997 p32 - 34

9) Julie Lazar, "Is It 'Uncommon Sense' to stop the estrangement between us?" in Uncommon Sense, The Museum of Contemporary Art, Los Angeles, 1997 p40 - 41

10) Marita Sturken "Negotiating Art: The Artist and the Museum" in Uncommon Sense, The Museum of Contemporary Art, Los Angeles, 1997 p.78

Selected Publications Patricia C. Phillips

"Public Art and Temporality," Art Journal, Fall 1989, p.331 - 335. (Reprinted in "Critical Issues in Public Art: Content, Context, and Controversy", Edited by Harriet F. Senie and Sally Webster, Harper Collins Publishers, Inc., New York, 1992 p.295 - 305.

"Out of Order: The Public Art Machine," Artforum, December 1989, p.92 - 98.

"Collecting Culture," in "Breakthroughs: Avant-Garde Artists in Europe and America, 1950 - 1990" (publication of the Wexner Center for the Arts, Columbus, Ohio), Rizzoli International Publications. New York. 1991. p.181 - 187.

"Invest in the Future: Patronize the Living Artist", in "Allocations: Art for a Natural and Artificial Environment". (publication for Allocations, Zoetermeer, The Netherlands). 1992. p.9 - 21.

"Images of Repossession", in Public Address: Krzystof Wodiczko, (publication for exhibition at the Walker Art Center, Minneapolis), 1992. p.37-43.

"Intelligible Images: The Dynamics of Disclosure", Landscape Journal, (publication for exhibition "Eco-Revelatory Design: Nature Constructed/Nature Revealed") Fall 1998. p.108-117.

"City Speculations", Princeton Architectural Press. New York 1998. (Editor and introductory essay)

"When Art is at Home", text for "Morphosis: The Crawford House". Rizzoli International Publications. New York. 1998.

"Ineffable Dimensions: Passages of Syntax and Scale", Ann Hamilton : Prsent-Past 1984- 1997 Musée Art Contemporain, Lyon 1998.

"It is Difficult" (monograph on the Work of Alfredo Jaar 1986 - 1997) Actar. Barcelona. 1998.

[Hugh Adams]

UN-FREEZING
&
RE-FREEZING

There are few cultural areas more myth-laden than those respecting the nature of the artist and the artist's education. Preceding discussion of almost any aspect of the higher education curriculum in Fine Art, let alone actually proceeding to change it, one would suppose that there should have been some pretty intensive research. However, there has been scant recent research on the number or nature of practising Fine Artists in this country[1].

Fine Artists are not mentioned in the recently published Government Creative Industries Task Force Mapping Document[2], which reported on the economic value of various arts professions on the domestic market and also in terms of export earnings. The lack of acknowledgement of the existence of contemporary Fine Arts practice, other than in the 'Fine Art and Antiques Market' section, is a sobering reminder of how our sector is regarded by the Government's Creative Industries Task Force. Relying on eight-year-old census statistics, the Task Force did not identify current Fine Art practice as being a separate major creative/productive constituency. Based on an early twentieth century idea of visual arts practice, the figures appear to be compounded in a general category in which Fine Artists are lumped together with commercial designers and the like. It is tempting to conclude that 'artist' was not featured as a separate occupational group because popular myth suggested that 'artist' was not a proper occupation or work of any social and financial significance.

As O'Brien and Feist have commented in their analysis of the 1991 census results, it is difficult to form an accurate assessment of the sector[3]. There is a lack in general of good quality, 'robust', statistical information using sensitive paradigms. However, it can be reported that negotiations are currently in progress between the Arts Council of England and the Office of Census and Population Surveys concerning the occupational classifications for the next census. The excellent Higher Education Statistics Office can provide current yearly statistics in respect of numbers graduating at all levels in Fine Art in the United Kingdom[4]. Apart from the work of Janet Summerton at Sussex University, there seems to be little current research specific to the economic activity of the Fine Artist. A report for Northern Arts, based on a survey of four thousand arts and cultural workers is imminent from Liz Davidson of Tyneside TEC. Linda Ball of Brighton University, is researching graduate employment in the crafts, for the Crafts Council[5]. David Clark Associates also undertook a similar investigation, 'Transaction Tracking'[6], for the European Commission and the Arts Council of Wales in 1996. Their investigation studied the financial transactions of twenty-five sole practitioners or small partnerships including artists, over a fixed period. Using Myerscough's methodology[7], this organisation with Cardiff University Business School surveyed the economic impact of the arts in Wales. A similar survey is in train for Manchester. Rod Fisher has been very active in the garnering of cultural statistics via CIRCLE (Cultural Information and Research Centres Liaison in Europe) and there is also work by EUROSTAT, the European Community's

statistics office.

Since such studies measure cultural industry in general, it is necessary to mine deeply to extrapolate evidence of what Fine Artists may be doing. Currently, the activity of the individual Fine Artist is being discussed in terms of 'micro-enterprise': a business, or quasi-business that employs one or two people. However this does not accommodate the motives, working patterns and aspirations of Fine Artists. The major danger in dancing with economists and those accustomed to apply business models, is that their criteria are based on economics rather than cultural values and may exclude the essence of what we are about and most treasure. A lack of fit will always arise when the major motive of those commissioning research lies in measuring economic success in conventional commercial terms, rather than in measuring cultural significance which is less easy to quantify. To counter the fact that many state organisations funding the arts have adopted indicators of quantity as criteria for worth, it is crucial that we apply precise and sensitive models to construct plausible, comparable enquiries that will inform our cultural policies and provide us with a realistic hope of constructing a curriculum reflecting the realities and complexities of professional practice.

To make any advances, it is necessary that we clarify what artists are currently doing. To be honest, I admit that I am far from understanding the exact nature of the artist beast and how the curriculum equips an artist to work. But I do know that the psychology and practice of artists is infinitely more complex than is presently officially acknowledged. Before we can consider what form of curriculum is

appropriate for art education then, we have first to consider the end-products, because we now know that an art school education goes beyond simply educating artists.

The myth that the artist and the art administrator are separate animals is fading, at least in the professional mind. No longer does the idea hold that the artist is only responsible to himself and his art rather than to his funders and audience, with the onus on the arts administrator to organise and manage "the circumstances" in which artists can create. In treating the nature of the artist we are dealing with a being working at the forefront of change. Alvin Toffler's description of a super-industrial society where old ways of thinking no longer fit the fast-emerging clash of new values and lifestyles[8] would seem particularly relevant to the artist, who has to cope with "discontinuous change" as Charles Handy has described it[9]. The artist is emancipated from the creaking linear change of the academy but has to cope with infinitely more complicated and multi-directional, quantum leaps! Writing on group dynamics, Kurt Lewins characterises such modes of change variously as: 'Freezing' i.e. clinging to what one knows; 'Unfreezing': exploring new ideas and approaches and 'Refreezing' - integrating new skills, attitudes and approaches[10].

Not all the traditionally held ideas of the attributes of the artist have become untrue. For instance most artists are still motivated by what Charles Handy calls "the love of the game"[11], which is not to say that they should be fobbed off with little financial reward as a result. The traditional attributes of the artist as someone able to think laterally and

promote creativity are still relevant[12]. But it is true that changes in the socio-cultural context means artists having to exercise themselves in a different climate.

After years of patronage and state hand-outs, artists are beginning to recognise that what little state money exists belongs to them more than badly educated bureaucrats. Artists are being more assertive about the circumstances in which they are prepared to claim it and ready to jump the administrative hurdles. Many good artists are emancipating themselves from what Oliver Bennet has called the "discourse of beleaguerment"[13]. I think we have to acknowledge that some artists still collude tacitly in maintaining this kind of image by continuing to foster the idea that they are in some nebulous way removed from real-world concerns, particularly when dealing with the nitty-gritty of contracts, rules and money. Indeed there is some evidence that some masochistically prefer beleaguerment!

There is also a further cultural sea-change as we begin to hear voices against the blandness of New Labour. As Jonathan Glancy reported in the Guardian newspaper, "the relentless dumbing-down of British culture is debasing the notion of excellence. Good, intelligent work still emerges but bogus democratic values are threatening to drown us in dross"[14].

THE ARTIST AT WORK

I have read and heard it said recently that the visual artist is inarticulate and usually unable to express ideas either verbally or literally with as much facility as they communicate through their art. As a 'truth', it ranks with that other quaint and risible idea that generally artists have few connections with the 'real' business of living, or with the business world for that matter. Many, if not most, conventionally successful artists have a sophisticated understanding of the various contexts in which they can combine the optimisation of their vision with reaping a reasonable material reward. They have become sufficiently chameleon-like to slip in and out of roles. Creative flexibility and adaptability, frequently born of erstwhile poverty, has now been turned to advantage in creative and other contexts. Many artists are lean and flexible 'businesses' and consider themselves as such.

Frequently artists welcome the increased complexity of their professional dialogue as a means to deliver the possibility of inventive and ambitious art as well as recognising the value of multi-faceted partnerships, which the dialogue now often involves, as delivering part of their desired audience. The new range of possible collaborations between artists and people in occupations and professional disciplines often far removed from their own has had the positive effect of stretching artists' expertise, their ability to communicate, to lead and work as part of a group. Of course many continue as before but there is considerably more realism about the value of hitching your wagon to a 'star system' which is increasingly seen as an outmoded and unhelpful model: a reality only for the few.

The metamorphosis of the solo artist into 'lead artist' of a project group or as a artist/curator, an artist/manager, an artist/architect and many other hybrid forms, is an instance of a 'portfolio' or 'kaleidoscope' worker i.e. one whose combination of work and life activities does not fit into a single occupational category. Artists elide classifications more than most

as we see in the phrases: artist-educators, artist-curators, artist-writers, artist-managers and even more elusive and complex permutations.

So where is the artist at this peculiar moment? Amidst rapid changes in technology and professional relationships, the artist has proved adroit at combining traditional and new skills. Opportunities are tremendous for artists who have no problems in abandoning notions of being the sole 'giver' or of paramount importance, in work involving other professionals but rather regard themselves as learners, possessed of specialist skills and approaches. As Thomas Mann said, "The wholeness of the human problem permits nobody, today less than ever, to separate the intellectual and artistic from the political and social, and to isolate himself within the ivory tower of the "cultural proper"[15]. This is as true now as it was in Germany in 1930s. The artist has been in the vanguard of recognising new networks for cultural distribution and has developed a well-honed knowledge of not only cultural policies but social and economic ones as well. Artists have become adept at new forms of collaboration, interfacing with the work of other agencies such as health, schools, business, industrial collaborations and urban regeneration schemes. True, many still cleave to conventional outlets and partnerships: galleries, universities and schools as traditional employers. Many rely on public art agencies, economic and environmental development partnerships and new kinds of markets and have, often of necessity, formed working relationships with a wide portfolio of other professional groups. They have developed insights into worlds other than the tight-sphinctered art village as well as new skills, such as diplomacy in dealing with often inflexible prerogatives and the practices of other professions. In a period of significant socio-cultural engineering and technological upheaval more rapid than at any time since the late nineteenth century, artists have been enormously responsive and increasingly involved in other sectors in developing non-gallery opportunities. Hence we have a position in which not only have the notions of artists' professional practice expanded but the types and combinations of what artists now recognise as 'work' have too.

The traditional skills have not vanished; creativity still lies alongside such things as judgement, critical acumen, imagination and sensitivity. But the old simple alliance of conceptual skill, combined with a narrow range of crafts skills, has gone. Sensual pleasure has not disappeared; illumination, insight, vision, intuition and euphoria are as much attributes of the artist working with a computer as they are of one using brush and canvas.

The socialisation of artists working with other professions has certain implications and raises the question of who may hold the title of artist as signifier of special creativity. Should we be talking about artists as a separate category at all? There has been considerable debate about modern pluralistic and co-operative notions of creativity, with words like demotic, democratic and participatory being bandied about as never before. The word 'art' in the recent past and certainly at present, can be construed in Alice in Wonderland fashion as meaning just what the user chooses it to mean[16]. Clearly this complicates the judgement of art but it also complicates things when we

97

contemplate notions of 'professional development' and ideas of art as social engagement. This is not to remove the status of 'specialness' from artists but it does recognise that artists' methods are akin to those scientists use to solve problems; artistic creativity is a teachable skill[17] and that artists, amongst other creative individuals, are totally committed to work[18]. This seems a more balanced view than the traditional one. Although research has shown that artists are not particularly exceptional in their thought processes and that the customary alliance of the artist with notions of special creativity and genius needs revision, these ideas seem neither to have penetrated popular mythology nor art schools.

ATTRIBUTES OF THE ARTIST

Britain has a profound problem. In its essentially philistine culture, the artist is
mythologised, demonised, stereotyped, celebrated and envied in turn. The angst-ridden, utopian bohemian is utterly confused with the potentially embarrassing radical free-spirit. Perhaps society is right to be suspicious in the light of all these mixed messages. Certainly in the view of Deborah Haynes, our society is far from thinking that "...art and making are normal and necessary parts of human activity in all cultures and at all times...". Haynes has identified as a peculiarity of contemporary artists that they are distinguished from artists of the past by their inability to envision a future with any confidence. She writes that at most points in the past people looked forward with a certain degree of confidence and planned prudently accordingly, "Many people, including artists, are presently unable to envision the future at all.... Now, most of us

feel as though the only future we can see is very close in time to the present.... In this context, there is a genuine need for both theoretical and practical discussions about the cultural function of the artist in contemporary society. We [i.e. artists, for she is an artist] must regain the capacity to act and to struggle, a capacity that is rooted in prophetic criticism and visionary imagination and is in many respects presently neutralised"[19].

To describe being an artist as a vocation sounds pretentious but it has been so described and as such 'vocation' has connotations of being drawn as if by a spiritual force (as in being 'called' to the priesthood). Possibly good for the image, but how about the reality?

That the gifts of the contemporary artist are legion, as well as the contexts in which they find themselves, goes without saying but let us think of some more of their supposed attributes: practitioner, thinker, critic, animateur, shaman, manager, social healer, lateral thinker, prophylactic against various kinds of social malaise, agent provocateur, craftsperson, business person, communicator, marketer, visionary, persuader, project manager, financial manager, thinker in residence, corporate court jester and producer of "symbolic weapons"[20].

Think what artists are held to believe: that art matters; that creativity is important; that working in an environment conducive to creativity is important; that making a living is important; that art has a moral dimension; that the conventional cash nexus is not all that important; that informality is important; that conventional career progression isn't important.

And what does 'the public' say about artists? As Arlene Goddard commented in

High Performance, 1995 on the American situation, "I would be able to start my own think tank if I had collected a dollar every time I heard someone say that artists are uniquely suited to be social visionaries, that artists can see beyond the constraints of real-politik to the true aspirations of a people, that artists are brilliant problem solvers, that artists can craft compelling visions of the future that can galvanise social action" [21]. That's America but the situation is the same here. All those justifications for the involvement of artists can be read in almost any document advocating public art or local authority report. I know, I have written some myself[22].

What else does today's artist need in the way of attributes?

Energy, resilience and tenacity; knowledge of historic and contemporary contexts; craft skills; entrepreneurship; information-gathering skills; insight; presentational skills; networking and personal relationship skills; team or project management skills, including critical path analysis; financial and legal skills; problem-solving skills; organisational and political nous. And that's without all the other possible combinations involved in portfolio or kaleidoscope working. Maybe I should add acting skills, for the public does so enjoy being titillated and scandalised by the stereotypical idea of the romantic artist, that it seems a pity to disappoint!

REMUNERATION OF ARTISTS

In the early 1980s, The Gulbenkian Enquiry went some way towards recognising the plurality of activity and reward open to artists[23]. Its survey supported the notion that selling was the main source of income for artists. But whilst it recognised that public support constituted an insignificant element in artists' incomes, it envisaged that artists' incomes would be extended through an increase in public subsidy rather than through a developed market, proper remuneration, or some other rewards system. This proposal seems rather olde worlde now, at a time when support for the individual artist in the form of purchases and unencumbered grants which buy time has almost disappeared. No-one dismisses the importance of grant-aid but one must be very clear and hard-nosed about the kinds of practice such aid most appropriately sustains and the worth of expending a lot of energy in trying to secure it. Frequently, it seems that logos, worn like campaign medals on all kinds of arts literature, testify as much to the degree of institutionalisation into the system and validation by that system, as indicating any significant funding input.

It is accepted that public support is needed to provide an infrastructure for the display of art that is 'non-marketable' by virtue of the fact that it is publicly owned, or that it is too difficult, too new, or too controversial for there to be sufficient general appreciation of it to allow a market to develop. We traditionally feel that the enlightened state has a role to play in providing such an infrastructure although it is bunkum that such subsidy must come from the state, as is amply demonstrated in a cursory examination of the programmes of private foundations such as Fundaciones das Caixas in Spain. However, it also should be recognised that Britain has fewer large private foundations than in mainland Europe and the United States. Grant-aid then ought not to be considered either as a substitute for or a

99

supplement to properly costed programmes and professional levels of remuneration. We still have an unwarranted emphasis on the place of grant-aid in our conversations and in our curriculum. It flies in the face of reality. At a time when Lottery Assessors have been paid in excess of three hundred pounds a day for advice, it would be considered expensive for artists working on placements to be paid half that rate. We need much less talk of the love of the game and more of proper levels of remuneration. How sad it is that artists barely aspire to the minimum levels of remuneration for actors and musicians. Apart from the ineffective engineering to establish Exhibition Payment Right, this is a nettle that the public sector arts funding bodies have yet to grasp. We need to teach our students where best to place their efforts. Certainly the case for an individual to chase grant aid is not persuasive. Equally, it should never be a place of first recourse, either solely for the income or with the idea of a more subtle sort of reward, for instance, in order to establish one on the success ladder.

Although the Gulbenkian Inquiry recommended an examination into how public funds were spent, this review eventually occurred by default in the late 1980s in response to what might be called a 'negative' opportunity. Then part of the new rhetoric of public support for the arts was that the creation of an arts infrastructure of public art agencies, training agencies, information banks and indexes would deliver a trickle-down reward for practitioners. The extent to which such an infrastructure delivered such a reward needs examining. Bodies charged with public arts support began to take an interest in infrastructural

development at approximately the same time as their funds and credibility began to decline. Systems of 'secondary support' began to be discussed. In a restrained sort of way, they became lobbying organisations for the application of Exhibition Payment Right and Per Cent for Art. They also exerted terrific pressure on local authorities to put their declining funds into the arts. The words 'strategic development' began to feature in their self-publicity. The cynic might say that this strategy was simply a way of sustaining credibility and relevance as self-perpetuating bureaucracies. However, this criticism would ignore the fact that some of these initiatives have been very successful in that public art agencies, in particular, as well as some local authorities, can point to some spectacular statistics respecting amounts of money going to artists.

Some of the initiatives need closer scrutiny and it is not always correct to treat the public arts support system as 'the enemy'. When I worked for a regional arts board, it was often very difficult to persuade artists not to conspire against their own best interests. Artists frequently thought that a poor financial deal was better than none and that if they did not take an opportunity then someone else would. Similarly, it was impossible to put pressure on galleries not adhering to the Exhibition Payment Right scheme since artists effectively undercut each other. The grant situation has worsened but the advent of contracts, residencies and public art commissions does offer much better rewards.

Things have also improved because many artists have had to emancipate themselves from being nursed. They have been made aware - sometimes at great

cost - that increased financial reward brings with it financial and legal responsibility. We owe much to artists and others, such as Artlaw and Artists' Newsletter (now AN Magazine), who continue to produce the publications that have created the bare bones of a framework of professional standards, advice and contracts.

Paradoxically, redirecting diminishing funds towards secondary support did lead to developing opportunities for some artists and equipped many others to capitalise on existing opportunities. It is impossible to regard these developments as negative, particularly as professional practice training (embracing topics like business skills, art law, public art, self-presentation, artists in education and so on) has been introduced into the provision of arts bureaucracies. These have now been refined, continuing as forms of post-qualification professional development. I still consider these among the most successful areas of cultural quango activity.

Recent pressure on artists and arts workers to become efficient 'economic units', with the concomitant pressure to respond to 'evaluation', has had advantages although it has often seemed unwelcome and frequently absurd. The tendency to evaluate the work of artists, of all kinds, solely in economic and social terms, has had an unforeseen effect on many artists, leading them to recognise their real worth and place a proper economic value on their activities in the market place. This has increased rewards at least for some and got them several rungs up the economic ladder. At last the majority of artists who sell directly from the studio, or through negotiating other outlets seem much better at placing a value on their experience and effort than hitherto. We have at last achieved some semblance of a more modern and dignified notion of working for a fair reward.

RECOMMENDATIONS FOR THE CURRICULUM

I feel that teaching institutions are still struggling with hide-bound values based on an early nineteenth century model that associates the artist with prophetic genius, alienation, madness and martyrdom for the cause of art. Certainly students seem to think so, but where do they get it from? Perhaps it is merely a reflection of society's confusion in understanding the value of artists' activity and difficulty in even deciding whether the word 'artist' is a term of praise or blame word.

It is upon vast and uncertain ideological marshlands that educators of 'artists' venture to tread! We discuss the curriculum; we discuss how we might best prepare our students for their professional lives. Most of what I have said about the nature of the artist today is based on anecdotal evidence and my observation, since hard facts are harder to come by. Creativity appears generally to be valued but there is uncertainty about the nature of those who go in for it professionally. To settle the uncertainty, some hard facts are needed, starting with establishing how many artists there actually are and thence establishing something of their true natures. Almost certainly, this would substantially change the cultivated as well as the popular mind. Despite all the odds, our Higher Education system in Fine Art continues to produce extremely inventive, elusive and creative people, of great versatility. Evidence shows that many

continue to practice as artists and others take their skills into different creative areas. Some vanish, at least statistically. If the vivacity of our visual culture and the international acclaim it receives are any measure, then to a large extent the education system works. But we cannot pretend either that it would not benefit from the occasional review and a little fixing here and there. However, it would be absurd to attempt fixing if we cannot demonstrate, with support from statistics, that it is actually broke.

We need much better quality statistics. The various departments of government need to follow up their rhetoric concerning the economic importance of the arts with hard research and credible figures concerning the number, the nature and the real economic and cultural importance of the fine artist. In order to bring credibility to our curriculum, we need to marry the resulting facts with far more precise information about what artists actually do in relation to new social pressures. Only with this information will it be possible to construct teaching programmes in the areas of professional practice and development responsive to needs and able to end the schisms between Fine Art higher education, the cultural quangos and life in the real world.

Much can be done in anticipation of this research. Although we are dealing with an area of immense volatility, we can begin creating a better quality of partnership with cultural quangos in order to ensure that professional development is a continual process and part of the art school curriculum. Post-qualification training ought not to be determined by whim and post-code.

This is not advocacy of a single curriculum requiring a grim conformity but a determined effort to see what might best feature where and when, in order to optimise how the professional experience of working artists could be integrated into the art school curriculum. I think that there is immense value and benefit to be gained from bridging the postgraduate professional development provision of the Regional Arts Boards and the professional practice courses in the art schools. Surely simple means can be devised so that there can be an organic relationship between each? It would bring a degree of maturity and real life experience to the curriculum and provide infrastructural support for post-qualification training.

We cannot assume that adequate post-qualification training will be delivered by present patterns of recruitment to our teaching staffs. We need a constant reappraisal of the realities of current practice if we are to provide our students with an educational experience equipping them properly for life after art school in the twenty-first century. The basic idea of the recruitment of contemporary practitioners to our art schools is good but to suppose that, without facts produced by research, we can identify the right people to deliver the best possible teaching programmes is simply flying blind.

Endnotes:

1) Adams, H. '...if it ain't broke...' paper given at 'Artists Education and the New Century' ELIA Conference, Helsinki, Autumn 1998. Publication forthcoming.

2) 'The Creative Industries Mapping Document' 1998 published by Department of Culture, Media & Sport (DCMS)

3) O'Brien, J & Feist, A (1998) 'Employment in the Arts and Cultural Industries', Arts Council of England. "Measuring the impact of the arts and

cultural industries is known to be problematic and there is little official information so that we can form an accurate assessment of this diverse sector"

4) 'First Destinations of Students Leaving Higher Education Institutions 1995-6' (1998) published by HESA (Higher Education Statistics Agency) Cheltenham.

5) Ball, L. (in press) 'First Destination Statistics for Crafts' survey for The Crafts Council. See also Ball, L & Price, E. (1999)'Graduates into Business' University of Brighton.

6)'Transaction Tracking' DCA (David Clark Associates), Cardiff. A similar cross-section survey was done by Janet Summerton for Southern Arts in 1999.

7) Myerscough, J. (1997) The Economic Significance of the Arts and Cultural Industries' Arts Council of England
Myerscough, J. (1988) 'The Economic Importance of the Arts in Britain' Policy Studies Institute

8) Toffler, Alvin (1980) 'The Finish'd Wave' Collins, London

9) Handy, Charles (1990) 'The Age of Unreason' Arrow Books, London

10) Lewins, Kurt (1951) 'Field Theory in Social Science' Harper and Row

11) Handy, Charles (1993) 'Understanding Organisations' Penguin, London and Morgan, Gareth (1993) 'Imaginization, the Creative Art of Management' paper given at Newbury Park conference in 1993, published by Sage

12) Handy, Charles (1990) 'The Age of Unreason' Arrow Books, London

13) Bennet, Oliver (1994) 'Cultural Policy and Management in the UK; an historical perspective' conference paper, Warwick University

14) Glancey, Jonathan (1998) 'Never Mind the Quality', November 21st, The Guardian Newspaper.

15) Mann, Thomas (1937) 'An Exchange of Letters', p.8, Knopf, New York,

16) Carroll, Lewis (undated) 'Alice Through the Looking Glass', p. 224, Heirloom Library edn. London

17) Weissburg, Robert W. (1986) 'Creativity, Genius and Other Myths' W.H. Freeman & Co., New York. See also: Patric, C. (1937) 'Creative Thought in Artists', #4 pp. 35-73, Journal of Psychology, and Eindhoven J.E. & Vinacke, W.E. (1952) 'Creative Processes in Painting' #47 pp. 139-164, General Journal of Psychology

18) Handy, Charles (1990) 'The Age of Unreason' Arrow Books, London

19) Haynes, Deborah (1997) 'The Profession of the Artist' Cambridge University Press, London

20) Bourdieu, P. & Haake, H. (1995) 'Free Exchange' Polity Press, Cambridge "Thanks to your artistic competence, you produce very powerful symbolic weapons which are capable of forcing journalists to speak, and to speak against the symbolic action exerted by corporations, particularly through their patronage or sponsorship. You make symbolic machines which function like snakes and make the public act.. They also make people talk about what the artist is talking about".

21) Goddard, Arlene (1995) 'What's Needed Now: a Call for Courage, Intelligence, Judgement and Guile', Summer, High Performance (journal).

22) Adams, H.; Iley, P.; Kay, D. and Kennedy, N. (1990) 'Art and Crafts Work' published by Southern Arts, Winchester

23) Pearson Nich. & Brighton, A. (1985) 'The Economic Situation of the Visual Artist' London, The Gulbenkian Foundation. This was never formally published, though informal copies exist. See also Pearson Nich. & Brighton, A. (1978) 'The Bristol Sample' Arnolfini Gallery, Bristol

[Jane Calow]

NEW
TERRITORIES
FOR ART
EDUCATION

FINDING NEW
PATHWAYS

Threatening the Contextual Practices Network (CPN) is a national network of Art and Design courses with a shared commitment to the teaching of contextual practice. The network meets regularly to disseminate information and discuss issues that arise out of contextual practice. What I want to do here is give some indication of the philosophy and structure of the group and to outline some of its specificities, while at the same time indicating some of the issues that arise through this initiative and which the network attempts to address. This network offers great support to educational initiatives in contextual practice that sometimes can feel isolated within departments and educational institutions. Isolation may still be experienced, even given a growing recognition of the importance of contextual practice by mainstream practice and even given the impact of post-modern practices upon education in Art and Design. This growing recognition of the importance of a contextual approach, coupled with an increased awareness of the need for students to acquire professional skills, puts pressure upon what may be described loosely as 'mainstream' practice to recognise some of the educational stratagems adopted by courses engaged in contextual practice.

CONTEXTUALISING CONTEXTS

The history of the Contextual Practices Network began when it was set up at a symposium held at Exeter School of Art and Design, University of Plymouth, February 1997. The primary purpose of the symposium was to set up a network of courses and programmes in Art and Design which specifically address notions of context within a given framework. This first symposium was organised by Judith Rugg from Exeter and John Carson from Central Saint Martin's, with the intention of creating a network of Further Education and Higher Education courses that included contextual practice within their curriculum. The network includes programmes and courses at BA and MA level in both Art and Design and in some cases, includes a large element of trans-disciplinarity. The structure of courses and programmes may differ in order to operate within the demands of the institutions within which they are housed and to meet the requirements of the kind of student that they aim to recruit. The establishment and structure of these courses and programmes varies from the course at Central Saint Martin's, (which has been operating for over ten years), to the 'Fine Art in Context' course at the University of the West of England (which moved from Dartington to Bristol), through to 'Fine Art: Contextual Practice' at the University of Plymouth (a new course) and finally to North Wales School of Art, which is currently in the process of setting up a new BA course in Public Art. This leads to discourse between established courses and new ones, enabling all to actively evolve by benefiting from voices of experience and new voices that may bring fresh perspectives to educational practice. The Network was born of a highly unusual initiative, given the climate of further and higher education at the time and indeed, the educational climate of the last ten to fifteen years. It was created at a point when the funding of colleges has decreased, when student grants are on the

way to being phased out completely and within an educational policy and ethos created originally by the Thatcherite ethos of the market place and seemingly continued under the aegis of the present government. This is a climate where students are sometimes referred to as 'customers' and where colleges appear increasingly set against each other as competitors for a decreasing pool of students. Despite this climate, the Contextual Practices Network set out to bring courses together that had like-minded commitment to the contextualisation of Art and Design practices and their dissemination through education. It was an initiative that resisted competition between courses in its aim to find out how we might support one another, raise the profile of contextual practice and strengthen it through sharing good educational practice.

The Network intended to open up and contribute to dialogue about both Art and Design practices and practices within education. Such a move indicates something of the ethos of contextual educational practice, as well as contextual Art and Design practices, where an emphasis is placed upon dialogue and discourse, rather than aggressive competition and the pursuit of individualism. What is energising about contributing to CPN is to have a sense of engagement with something of a shared vision, which at the same time makes room for and recognises difference. CPN explores differences in aims and objectives of particular courses and programmes: differences in emphasis, in ideological position, differences in the constituencies that we address (both inside and outside the institution), differences in the kinds of

students we cater for and different approaches to our understanding of what constitutes theoretical contextualisation and its relation to making. The Network is predicated upon collaboration and the idea of belonging to - and contributing to - a discursive community. This is in contrast to the broader frame of Art and Design education which I consider still carries, through its methods of teaching and learning, traces of a tacit tendency towards reinforcing the notion of lone inspired individuals producing works of 'originality', or at the very least novelty, within the confines of an unexpurgated notion of art as self-referential and 'expressive.' This covers old ground, I know, and is somewhat strongly stated and a touch reductionist perhaps, but I think that it does have some bearing upon the relation of 'mainstream' practice to contextual practice, which comes out of a very different historical and ideological frame. Nevertheless, 'mainstream' Art and Design education increasingly recognises the need to equip students with the practical negotiating and professional skills needed to survive as a practitioner today; skills that are part and parcel of a contextual approach to practice. This does not, however, mean that so-called 'mainstream' courses subscribe to many of the underlying constructs that define contextual practices - although it must be said that the recognition by 'mainstream' practice of the importance of certain skills previously associated almost exclusively with a contextual approach is leading to greater dialogue across borders.

The original objective of CPN was to establish a national network of Art and Design courses which included elements of developing relationships with external

agencies/residencies/the public realm/aspects of community and which encouraged students to locate and address their working concerns within an 'outside' and theorised context. It was intended that the network should function as an academic framework to develop teaching and learning in this area, to support courses enabling effective learning outside the institution and to develop a research group in which aspects of context may be discussed and disseminated. CPN seeks also to encourage quality and learning and research in education for Art and Design, specifically in terms of practices contextualised by social settings. It seeks to increase awareness of such developments in other areas of Art and Design education and in other relevant disciplines.

So what is practice, and what might be understood by context? An emphasis upon Art and Design as 'practice' as against Art and Design as 'product/object' relations changes the prominence that certain sets of relations have over and above others and duly recognises the place for post-modernist stratagems. The idea of Art and Design as practice moves away from an emphasis upon consumption and the stress placed upon the static object towards something that places greater value upon active engagement. It moves away from the idea of the isolated production of an object encountered by a sole viewer - an object that must be consumed correctly. Understanding Art and Design as practice is to explore and critique Art and Design, recognising it as dynamic and dialogical. Art and Design as part of practice must also consider the conditions of practice. It is intentionally dialogical and reflective from the outset.

Such a perspective has implications for teaching and learning methods and issues around collaboration between students and other constituencies and indeed the assessment of student work.

EDUCATION AS PRACTICE

To consider education within this frame is to take on an expanded notion of education with new teaching and learning methods, which do not necessarily eradicate the importance and highly determined places of the studio and gallery, but which do want to question and challenge the conventions and the modernist tradition of the centrality of studio/gallery. Art and Design educational practice that considers context means questioning art education that replicates the modernist conditions of the studio. To engage actively with practice of necessity means engaging with context. The documentation of the 'Visual Arts in Context' course at the University of Salford proposes that an intrinsic element of 'context' is to perceive it as, "The interactive space between the subjective (author) and the 'other', in other words, what is it to consider gallery as context and studio as context?" This is an apposite commentary in the light of post-modern stratagems and the impact of new technologies which have changed the conditions of making, location and relation to audience. Understanding Art and Design practices and educational practice as dynamic means that many of the courses and programmes belonging to CPN have to address concerns that would not necessarily arise within the 'mainstream', in particular, what is the place and status of the documentation of projects and their status within assessment? Discussion

within the Network has raised some important points such as the problem of assessing invisible things in a non-product-based practice. As John Carson has noted, some projects produce quite dramatic direct results, where others that are more indirect may not materialise until after the student has left college. A failed project may be a success as far as the student's perception and learning goes; the process is more important than the results. Therefore the evaluation report may be more important in assessment than the specific outcome. Most, if not all, of the courses and programmes belonging to the Network are developing methods to enable students to produce reflective documentation, rather than just producing objects.

Documentation is an area that I personally consider to be of increasing consequence, as is already suggested by the part it has played in raising the profile of new genre and activist arts practices in America. Many of the problematics that arise with documentation (e.g. what is its status in relation to practice? When might documentation become object/text in its own right?) are relevant to the consideration of documentation with regards to student practice. Documentation also needs to be considered with regard to research into contextual practice, given the research culture's hierarchisation of the international over the national and the regional. Whatever happened to the post-modern discourse around space and place, I ask myself? It is necessary to engage with the institution of Art and Design education and to produce new methodologies in teaching and learning in order to critique the institution of

education itself and to expand its boundaries, so that students are encouraged and given the opportunity to equip themselves with the necessary skills to become reflective, confident and ethical practitioners/facilitators.

As David Trend has observed, drawing upon Gramsci: "Every relationship of hegemony is necessarily an educational relationship." David Trend describes critical pedagogy as a concept which draws attention to the process through which knowledge is produced, including analysis of what kinds of thinking/practices are legitimated in teaching, as well as the discursive relations and power configurations that enable the process. Education occurs within the conditions of hegemonic process; understanding the context of education is to see it as a site of contestation and uneven power relations. It is to understand that within the conditions of post-modernity, we have to be alert to the need to invent new strategies in terms of artistic practice and education. We have to be sensitive to and learn to recognise emergent practices with evolving languages, where Art and Design practice can be understood as communication, representation and above all dialogical. I don't think it would be out of order to say that many of the people engaged in contextual practices were drawn to it through personal experience and conviction. The threads of practices, ideologies, and what has critically informed these practices, weave together to make contextual practices distinct from 'mainstream' practice. The work in communities during the 1960s and the will to circumnavigate the gallery system in the 1970s, coupled with the emergence of practices that explored issues of

identity, developments in new technologies, developments in critical practices such as cultural studies, feminist art histories, cultural geography, media studies - the list is too long to go on - and the influence of practice and thought that has come out of America over recent years, all feed into the development of contextual practices and gives them their distinct flavour.

CHARACTERISTICS OF NETWORK COURSES

In his paper, 'Context is Half the Work', David Harding asked us to consider the discourse of 'environment' (the meaning of public art, community, site, space and place) and to consider the transience or permanence of art practice, climate, materials etc. in conjunction to art education. All of these are considerations pertinent to the content of many of the programmes and courses contributing to the network which aim to produce politically aware and socially engaged approaches to art practice. At the Contextual Practice symposium held in 1997, commonalties of approach to context were discussed and a number of commonalties between courses and programmes specific to contextual practice emerged. It was considered that students taking contextual practice as an option are more likely to require a deeper understanding of the broader environment than that of the studio. Students must take on issues of audience and the social space of sites, ask questions about how art functions and operates within society and develop critical practice which is integrated with making skills. Students must also develop good presentation, communication and negotiation skills in

order to set and plan projects and to work with outside organisations.

Through engaging with 'place', students must also examine the social relevance of what they do. The 'Visual Arts in Context' programme at the University of Salford posited the question: "What is the operative role/function/position of context in the education/training and development of creative artistic practice?" concluding that context might be understood as the framing space for arts production. This course also suggested that context might be understood as border spaces for negotiation between Art and Design and other fields. What is it to consider the utilisation of context as a pedagogical tool? This question again raises issues not only about what is taught, but also raises questions around the context within which it is taught, namely, the place of the Art and Design institutions. While in post-modernist terms it might be said that centres and margins have been fractured and that it is no longer helpful or precise enough to talk about being either 'inside' or 'outside' of institutions in any definitive manner, the power relations integral to hegemonic process have to be acknowledged and stratagems put in place to work as effectively as possible. As Tim Dunbar proposed, the understanding of context in Salford is driven by: "A concept of contextual arts practice motivated by an aesthetic/ideological position which is located in a social arts or interventionist arts tradition." It lists contexts as personal/physical/historical/economic/social/socio-political/institutional/cultural and national/European/international. All of the courses that contribute to CPN address context through the design and structure of their programmes of study. Many of the

courses, such as Salford, and 'Fine Art in Context' at University of West of England, favour a media-independent approach to practice with an emphasis upon ideas and issues. Other courses, such as the MA in 'Art and Design in Context' at the University of Sunderland, offer a range of media choices. Some of the programmes of study work as a strand within Fine Art, for example the work done by Alain Ayers at Nottingham/Trent University, while others may offer it at certain levels of study as electives, such as the programme offered by Val Murray at the University of Central Lancashire. Different courses lay emphasis upon the many threads that define contextual practice. Not all courses are focused upon placements for example, but place an emphasis upon contextualisation through theorisation and critical practice. Examples of this are the specialist BA and MA courses run by Chelsea, which are based within the School of Design and explore theory and practice in Design and Public Art.

The Contextual Practice Network acknowledges the value of the integration of critical practice with material practice; this is a fruitful area for a great deal of further work. Analysing the manner in which theory is integrated with practice within different programmes and courses contributes greatly to the understanding of Art and Design practice - not just in terms of the direct value that this has to Art and Design education - but also through the manner in which analysis of the relation between critical and material practice contributes to the understanding of Arts and Design practices as a whole.

SOME CONTEXTUAL PROJECTS

Green and environmental issues are considered by many of the Network's courses and programmes; with certain courses, such as the MA in 'Art and Environment' at Manchester Metropolitan University and 'Design for Environment' at Chelsea, highlighting the importance of environment within their curriculum. In 1995, the Manchester Metropolitan University co-founded the International Institute of Art and Environment (INIFAE); a network of academic and arts organisations devoted to research and development of best practice within the field of environmental Art and Design.

Here are two brief descriptions of projects undertaken by Art as Environment. 'Sul Suolo', completed in 1997, was an environmental art project at Villa Lais, a small park in Rome, where students worked with the staff and patients at Centro di Urno, a day centre situated in the park for people with psychiatric problems. To research, develop and produce new designs for the park, the team also worked in collaboration with students from Rome, professional landscape architects, artists and designers. As part of the Artstranspennine '98 project, the course worked with Helen Mayer and Newton Harrison on the development of their ongoing interdisciplinary project work 'Casting a Green Net: Can it be We See a Dragon? completed in January 1998. Past student residencies and placements undertaken by 'Fine Art in Context' at the University of Plymouth have included working with the Tate Gallery, St. Ives, London Contemporary Dance, British Steel, Channingswood Prison and more. Residencies abroad include Egypt, Morocco, Brazil, Israel and India, as well as Europe. Amongst other courses, 'Fine Art in Context' at the

111

University of the West of England and Central Saint Martins have students working on diverse placements both here and abroad.

WHERE TO FROM HERE?

The Contextual Practice Network has a mailbase at the University of Plymouth, which is gradually attracting members not only from Art and Design but from other fields and disciplines. Possibilities for setting up the equivalent of 'Fresh Art' as a way of presenting projects has been discussed and plans for another symposium are in hand. Objectives still include a network for students and clients, including a directory of clients and the ongoing development of teaching and learning. CPN is committed to supporting courses that enable effective learning outside of institutions. Other aims are to provide support for students through meeting other students undertaking contextual practice in other institutions belonging to CPN. In addition, the formation of a research group and the production of a text on contextual practice are under discussion.

Many of the issues touched upon here are under constant review and produce lively discussion within the Network. Arts practices are evolving at an accelerating rate and educational institutions find themselves operating within ever more unstable conditions. Putting these two factors together means that in order to be effective, Art and Design education must understand the structures it operates within; the Contextual Practices Network offers an imaginative and appropriate response to the present climate.

References:

Carson, John (1997) Appendix 1 of Contextual Practice Symposium Exeter School of Art & Design, University of Plymouth

Dunbar, Tim (1997) Appendix 3 Contextual Practice Symposium Exeter School of Art & Design, University of Plymouth

Harding, David (1993) 'The Context is Half the Work' from 'Issues in Art, Architecture and Design' Vol.3 (1) pp. 613, University of East London

Trend, David (1998) 'Cultural Struggle and Educational Activism' p. 175 in ed. G.H. Kester, 'Art, Activism and Oppositionality Essays from AfterImage', published Duke University Press, Durham and London

[Judith Rugg]

FAST FORWARD

BEYOND THE BUBBLE

The 'Out of the Bubble' conference and this publication of its presentations have a two-fold aim: to highlight the diversities of 'contextual practice' in art and design and to provide a forum for discussion as to its definition. Attempting to define 'contextual practice' has been an ongoing concern of the Contextual Practice Network through its electronic discussion network and through discussion of pedagogical issues.

Essentially, contextual practice remains distinctive in that it arises from considerations of place. It has an interest in the interdisciplinary as well as the multidisciplinary, in spatial theory and in relationships between process, object and aspects of collaboration. However, when a definition is sought, the diversity of practices is highlighted and gives rise to problems, as was shown by the range of perspectives, practices and approaches presented at conference and in the discussion sessions.

Edwina fitzPatrick's description of her inIVA residency in industry and her site-specific projects, 'Returning the Stolen Water' and 'Flow Chart' focuses on the importance of process in informing ideas for art works. Her interaction over a long period with the people involved in the places where the works took place was essential for her perception of the work. She raises some useful questions about the importance of the reflective process when making what she calls a "site responsive artwork" and devising ways for this to take place. 'Flow Chart' depended on trust being established between the artist and those with whom she was working. For the work to take place, the support of the community was essential. The freezer which housed the final work can be seen as an apt metaphor for the dependence of site-responsive work on the building of trust with a group of people. For fitzPatrick, such a fragile relationship is painstakingly reinvented with every new work.

Edwina fitzPatrick's questioning whether the artist can ever become the 'insider' in working with people is similarly examined by Patricia Phillips. She questions the artist's effectiveness in some contexts: do the artist's good intentions necessarily have 'good' effects? 'Culture in Action' is one example of work which questions 'object-driven' public art but one which may be problematic in terms of matching good intentions with good effects. Phillips cites Miwon Kwon's own questioning of the effectiveness of potentially formulaic approaches, based on fixed and artificial perceptions, to working with groups which may have the result that those groups are exploited and therefore silenced.

Phillips suggests that perhaps only a sustained involvement with a site such as that demonstrated by Mierle Laderman Ukeles' longterm involvement with the New York Sanitation Department, can truly engage with its issues. In conclusion, she offers some key characteristics of contextual practice as "decentralised, discursive, critical and challenging" as an opposition to 'conventional' public art.

Aspects of collaboration and the interdisciplinary are seen by Platform, a multi-disciplinary organisation working

for social change through creative projects, as essential components in its work. The process of its interactions with people through public meetings, networking, guided walks and discussion overshadows any concern with the creation of an object. Provocation in encouraging people to consider technological and environmental issues are part of its form of contextual practice. Platform's work is based on the assumption that it has a societal impact which its sees as the artwork and it sees a clear distinction between concepts of 'place' as opposed to those of 'site' thereby problematising accepted notions of public art.

In its concern with 'place', contextual practice is linked with notions of the public sphere, which Adam Chodzko identifies as a network of communications, exchange and engagement which is therefore in constant flux and transformation. His practice is an attempt to represent this public sphere through setting up a communications 'space' and identifying its flaws which he describes as a way to look within it. Chodzko's concern is with the margins, the background and the peripheral and with the collapsing of past and present. His various approaches and methods to reveal this unseen space focus on an essentially human interaction with the public sphere he identifies.

Alison Marchant talks about the experience of space and place and how that experience is affected by the threat of redevelopment. Using a variety of strategies to engage with people on Holly Street Estate she sees aspects of the spoken word as part of the process of this engagement and exemplified by "breathing, movements, pauses, whispers and tape noise" - evoking and identifying a personal space within the impersonal one of redevelopment. Her resulting bookwork, 'The Living Room' partly represents this process of communication and collaboration and in her presentation at the conference was manifested through a different form (CD-ROM and sound), suggesting that contextual practices can be fluid and take different forms in the same project.

The Contextual Practice Network currently has 25 members representing 16 different institutions and Higher Education programmes, all of which are related yet distinct from Fine Art and Design courses. This reflects both the growth of academic interest and the relating shifts in contemporary art practices. Since the first conference in 1997 there have been several developments. In the 'real world', beyond the bubble of academe and its sometimes idealistic framework, there is an expanding interest amongst curators, artists and funding bodies in creating opportunities for artists to develop projects outside galleries and outside the often straitjacketed definitions of public art. These projects have in turn developed links and interdisciplinary practices with other fields such as science, many of which involve an engagement with place. In the continuing symbiosis, new undergraduate and postgraduate courses have appeared which focus on the relationship between art and space and the dialogue between spatial practices and art processes which take place outside the studio.

Since that time also, new research

units within institutions represented in the Network have been established to focus upon developing the discourse within this area. Each research centre is distinct, for example the Art and Urban Futures Research Unit at the University of Plymouth, the Research Centre for Contextual and Commemorative Practices at the University of the West of England and the Unit for Social Sculpture at Oxford Brookes University. Over the next twelve months new texts which investigate the relationships between art and space, will be published as part of the outcome of these research units and of collaborations between Network members.

The Network has now changed its name to Contextual Practices in Art and Design to include Design courses and programmes which share an interest in theorising the relationship between design, spatial issues and the process of collaboration, and recognising a variety of practices which do not necessarily include conventional object-making. It has also established a programme of twice yearly seminars to be rotated at member institutions, giving the opportunity for the presentation of papers and the development of the discourse.

The Network also hopes to create annual opportunities for its students from our different member institutions to come together in a formal and supportive way for the dissemination of ideas and projects.

Continuing to meet in person and on-line to discuss the distinctive elements of contextual practices and to disseminate ideas, the Network remains idealistic. Its five-year plan includes the design and application of new software in its electronic forum which will allow faster and more accessible forms of dissemination. It intends to host more conferences, symposia and seminars and to publish texts relevant to our students and to the wider community. Currently, although there are many new books about artists in the wider environment, there is little published which brings ideas and issues together. The Network believes that the considerable body of knowledge and teaching/learning experience in relation to contextual arts practices needs to be recognised more widely and consolidated within the institutional framework of the Fine Art education system.

BIOGRAPHIES

HUGH ADAMS

Hugh Adams is Research Fellow at the Centre for Research in Fine At, University of Wales Institute, Cardiff. He also teaches Arts Management as Sussex University and runs the 'Art Agency', a research, consultancy and commissions agency.

JANE CALOW

Jane Calow is a freelance researcher and artist currently undertaking a PhD in art practice at the University of Leeds. Until recently she was Head of Fine Art as Social Practice at the University of Wolverhampton. She is also external examiner for Fine Art in Context at the University of the West of England.

JOHN CARSON

John Carson is an artist who works in video, audio, live performance and installation. From 1985 to 1991, he was Production Manager at Artangel, working on temporary arts projects in public situations. Since 1991, he has worked on the B.A. Fine Art course at Central Saint Martins College of Art and Design, initially as co-ordinator of placements and external projects and currently Course Director. He has been an advisor and consultant to organisations such as London Electronic Arts (now The Lux Centre), Public Art Development Trust, BBC Television, London Arts Board and The Arts Council of England, for whom he has recently been researching ways of improving professional practice provision within Fine Art education in the U.K.

ADAM CHODZKO

Adam Chodzko is an artist. Born in 1965, he gained a B.A.(Hons) degree in Art History at Manchester University and a Masters Degree in Fine Art at Goldsmiths College, London. Lives and works in London.

EDWINA FITZPATRICK

Born in 1961 in Nottingham, Edwina fitzPatrick currently lives and works in London. She began training as an architect, but transferred to BA (Hons) Expressive Arts at Brighton Polytechnic. She has exhibited widely in British and European galleries, however recent work has increasingly focussed on non-gallery spaces. Recent projects have included 'Cultivar' an indoor hydroponic apple orchard in Bishopsgate Goodsyard railway arches, East London; commissioned by Slow Release. She is currently involved with the Exeter based 'Windowsills' project, commissioned by Spacex Gallery and Plymouth University.

RICHARD HYLTON

Richard Hylton is a curator/artist and writer of art criticism. He is currently a curator at Autograph. He is also a member of the art music group 'Die Kunst'. Selected Exhibitions: 1998 'Organic City', commission for Photo '98 Impressions Gallery, York, 1997: 'Connected': Northern Gallery for Contemporary Art; 1996 'Bank TV', London and Manchester; Bath Music & Visual Arts Festival: Video installation in collaboration with Bashir Makhoul; 1993 'Black People and the British Flag', Cornerhouse, Manchester.

KEITH KHAN

Keith Khan's work engages with popular culture and audiences in different ways from gallery work through to carnival. Currently joint artistic director with Ali Zaidi of 'Moti Roti', a company which creates an interface between the mainstream and changing cultural identities, Keith Khan trained as a sculptor and has designed many projects for theatre, opera and television and recently was part of the creative team for the Millenium Dome Central Attraction Show. He has been an advisor to national and regional funding bodies on developing new strategies in public art and collaborative practice.

JOHN KINDNESS

Born in Belfast 1951 and studied Fine Art at the College of Art in Belfast; took ten years to recover from the experience. Involved in underground comics and television graphics. June 1978 married Danae Campbell. 1986 went back to making art full-time. 1989/90 PS1 fellowship - an influential year in New York. 1991 Moved to Dublin and began working on public commissions. Currently living in Tullow, County Carlow alternating personal projects with commissioned work. His work is held in the public collections of Irish Museum of Modern Art, Dublin, Boston Museum of Fine Art, Ulster Museum Belfast, National Gallery of Ireland, Hugh Lane Gallery, Dublin, The British Council, Imperial War Museum London, and the Victoria and Albert Museum, London.

ALISON MARCHANT

Alison Marchant is an installation artist based in East London. She studied at the Slade School of Art under Susan Hiller and Tim Head and is currently Senior Lecturer and Subject Leader for the Photo-visual area of the B.A. Fine Art course at University of Wales Institute, Cardiff. She is known for her work with found and archive photographs involving research practices. An important part of her work is her on-going concern with working with non-art communities and how to bring this work into a wider area/audience. With these aspects in mind, she creates poetic installations and sites specific works which involve many contributors. She has exhibited both nationally and internationally, and is currently producing a major art project across East London enlarging family photographs onto fifty billboards.

SUZANNE OXENAAR

Suzan Oxenaar is an independent curator who has initiated and hosted a large number of art and theatre projects. Under the authority of the Mondrian Foundation she has commissioned public art works for city councils, hospitals, mental institutions, convalescent homes and other organisations. At present she is occupied with the development of a hotel, that is bound to become an asset to the Amsterdam art world at large.

PATRICIA C. PHILLIPS

Patricia C. Phillips is an independent art critic, curator and educationalist. Her writing concerns public art, architecture, design and sculpture and the intersection of these areas and is widely published in America and internationally. In the last two years, she has published essays and texts on contemporary landscapes, public art and individual artists such as Ann Hamilton, Alfredo Jaar, Rimer Cardillo and the architects Morphosis. In 1996, she curated the exhibitions, "Making Sense: Five Installations on Sensation" at the Katonah Museum of Art and "City Speculations" at the Queens Museum of Art. She is currently Dean of the School of Fine and Performing Arts at the State University of New York at New Paltz.

PLATFORM

Since 1984, PLATFORM has established itself as one of Europe's leading exponents of social practice art, combining the talents of artists, scientists, activists and ecologists to work across disciplines on issues of social and environmental justice. PLATFORM is London-based and makes work arising from the nature, history and impact of the city, and the valley which gave birth to it: the Thames.

JUDITH RUGG

Judith Rugg is Programme Co-ordinator of Fine
Art Contextual Practice at Exeter School of Art
& Design, University of Plymouth and a founder
member of Contextual Practices in Art & Design
Network (formally the Contextual Practice
Network). She is currently researching a PhD on
gender and public art at Middlesex University
entitled 'Sited Works: The Context for Artistic
Practice for Contemporary Women Artists.'

SUSANNAH SILVER

Susannah Silver is an artist, researcher and
writer specialising in issues of professional
practice for artists working in communities and
public contexts. Her doctoral research,
completed in August 1999, examined the
decision-making processes of artists
undertaking a 'real-world' urban arts project
('Taming Goliath') in North-East Scotland and
developed a new model of creativity which
makes such processes explicit. She undertakes
participatory arts projects in urban and rural
communities as part of continuing research into
Contextual Arts practice and its implications for
the professional status of the artist.

GERRIE VAN NOORD

Art Historian. Formerly Exhibitions Organiser at
De Appel in Amsterdam as well as Co-Founder
and Coordinator of De Appel's Curatorial
Training Programme (1993-1996). Worked at
the Rijksakademie van Beeldende Kunsten in
Amsterdam (1988-1992) in several positions,
last of which was Fundraising Co-oordinator.
Has since 1989 produced magazines, books and
catalogues. Currently Head of Publications &
Communications at Artangel and also works as
a free-lance editor and translator.